creative
JOLT

creative jolt. Copyright © 2000 by Robin Landa, Rose Gonnella and Denise M. Anderson. Manufactured in Singapore. All rights reserved. No part of this book may be reproduced in any form or by any electronic or mechanical means including information storage and retrieval systems without permission in writing from the publisher, except by a reviewer, who may quote brief passages in a review. Published by North Light Books, an imprint of F&W Publications, Inc., 1507 Dana Avenue, Cincinnati, Ohio 45207. (800) 289-0963. First edition.

Visit our Web site at www.howdesign.com for more resources for graphic designers.

05 04 03 02 01 5 4 3 2 1

Library of Congress Cataloging-in-Publication Data

Landa, Robin.
 Creative jolt / Robin Landa, Denise M. Anderson, Rose Gonnella.
 p. cm.
 Includes index.
 ISBN 1-58180-011-8 pbk. : alk. paper)
 1. Commercial art—Technique. 2. Graphic arts—Technique.
 3. Visual communication—Psychological aspects. I. Anderson, Denise M.
 II. Gonnella, Rose. III. Title.
NC1000.L358 2000
741.6—dc21 00-056249

editors: lynn haller and linda hwang
design: dma
art director: denise m. anderson
designers: denise m. anderson, rose gonnella and robin landa
design assistants: laura menza, alejandro medina, cesar rubin, katherine schlesinger, jenny calderon and bran bogdanovic
production artist: ben rucker
production coordinator: kristen heller
cover concept: robin landa
cover art credits: © Yvonne Buchanan 1998; © Sommese Design; © Time Warner Audio Entertainment; © David N. Wheeler; © Viva Dolan Communications and Design Inc.

The permissions on page 140 constitute an extension of this copyright page.

acknowledgments

We are very grateful to all the creative professionals who were so generous with their time, and allowed us to reproduce their outstanding work in this book. Their names are individually listed in the credits and we bow to their talent. This book is, in part, dedicated to the creative professionals who are creating the visual artifacts of our time.

Great thanks to Laura Menza, Katherine Schlesinger, Alejandro Medina, Cesar Rubin, Bran Bogdanovic, Jenny Calderon, and Shana Acosta, for their design assistance and tireless research. Thanks to Paula Bosco for help with the index and to Janet DeAugustine for help with typing.

Much thanks to the top team at North Light Books: Lynn Haller, acquisitions editor; Linda Hwang, editor; and Clare Finney, art director.

Loving thanks to our families and friends who suffered our absence whilst we worked.

Rose thanks her wonderful Mom, Josephine, and Dad, Joseph, who thought for a few moments that perhaps they didn't have a second daughter. She also thanks her wonderful students, from whom she learns something new everyday.

Denise thanks her parents, Maureen and Frank, her wonderful family and close friends for their unconditional love and support. She thanks her nephew, Jerry, and nieces Nicole and Jenny for teaching her new ways to see the world and her children, Polo and Truffles, for the sanity needed to survive the world. Denise would also like to give special thanks to Paula for showing her colors she has never seen before.

Robin gives sweet thanks to her husband and suave dance partner, Dr. Harry Gruenspan, and their precious baby, Princess Hayley Meredith. Many thanks to lovely Linda Freire who took loving care of Hayley, (while Hayley's Mommy worked on this book) and to Linda's dear husband, Edmundo Alcantara, and their *dulce y bonita* daughters, Michelle and Cynthia. Also thanks to esteemed friends, Dr. John Chaffee and Dr. Richard Nochimson, for their wise words included in this book. Robin dedicates this book to the memory of her beautiful mother Betty Landa, who is dearly missed.

We would like to recognize the passing of designer Rick Eiber.

table of contents

SAN FRANCISCO PERFoRMANCe

mar.

pRESENTS

| 25 | 26 | 28 | 29 |

ACT II scene I

CO.

wIM vANDEKEYBUS /
uLTIMA vEZ

scene II

SAN FRANCISCO performances

introduction

1

jolt: to move or dislodge with a sudden, hard blow; strike heavily or jarringly.

"communication is a language that requires different voices. if it doesn't take a chance, it doesn't have a chance."

carlos segura, segura inc./chicago, il

We all have our comfort zone. Some designers rely on a favorite color or border, some always use the same grid; others use the same illustrator or printing technique. Yet when one feels comfortable, one is less likely to take chances. One is more likely to return again and again to similar design solutions. Feeling comfortable is not good for a designer.

It seems that most people prefer feeling comfortable even if they are dissatisfied with the status quo. As any pop psychologist would attest, people stay in relationships that are not satisfying because they are comfortable and prefer to avoid the anxiety of change, as well as the prospect of another relationship that doesn't satisfy. Similarly with design. Doing something you've never done, leaving the comfort zone, can make a designer feel uncomfortable. However…for any creative professional, discomfort is good.

For many a creative professional, a lull in creativity may easily go unnoticed. Perhaps, you don't realize that you've stopped tapping into your creative potential. Or, it could be that you've lost the desire to explore, or even grow beyond what you know well. For example, if one draws successfully and feels comfortable utilizing pen or pencil, then why pick up a twig and draw

Two spreads for the book WhereIsHere *published by Booth-Clibborn, designed by Laurie and Scott Makela. "Spread one talks about the design versus the fine art world," says Stefan Sagmeister; "on spread two Hjalti Karlsson cut the type into my back with an X-acto knife. Yes, those dangling things are my balls."*

title: *whereishere*
description: spreads
design studio: sagmeister inc./new york, ny
concept & design: stefan sagmeister
photographer: tom schierlitz
illustrator: kevin murphy

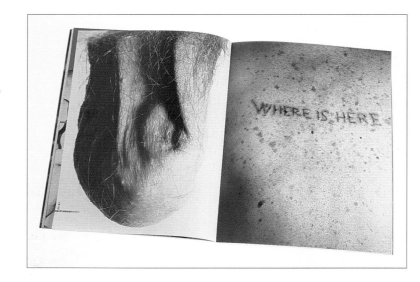

with it? There is a reluctance, and quite understandably so, to try a new tool. New things may not work out. When five classic typefaces have served you well, why try a funky font or use your own scrawl? When your clients are happy, why risk change?

On the other hand, some of us do want to explore, try new methods, or take a creative leap out of the safe zone and into the spot where exhilarating ideas can happen. But perhaps an inspirational push is necessary in order to make the leap. Creative jolts can help. This book will dislodge you from your comfort zone. It will jolt your creativity loose, keeping your work exciting and fresh for both you and your clients.

Creative Jolt focuses on creative approaches used in graphic design, advertising, illustration, typography and photography. This book contains designs in a broad range of styles, applications and directions. We focus on the creative thinking involved in each piece and how it can jolt *your* thinking. Along with the ideas presented in the various chapters, the following is advice on creative visual thinking and how to find, receive or self-inflict a creative jolt.

Hjalti Karlsson cut type into Sagmeister's back with an X-acto knife for a spread for *WhereIsHere*; talk about inflicting a jolt!

Here's how you jolt yourself out of your comfort zone:

let someone take you there

Whether you're a designer, illustrator or artist, you probably return again and again to a favorite room or artist in your local museum. You prefer to see what you enjoy, what you've always appreciated. Of course, you'll go see the latest exhibit, but how often do you go to another wing or room? If you always go look at the Moderns, do you ever go look at the Baroque? If you enjoy paintings, do you ever go look at sculpture? If you love the Far East, do you ever look at African art?

Let someone else take you to the museum. Go where a friend takes you. You might be delightfully engaged by what you find.

Of course, this does not apply only to museum-going. Trying to see from other points of view or new vantage points, going to a film by a master of modern cinema you wouldn't ordinarily choose, reading a good author you've never read (or even have avoided)…all can act as eye-openers.

The creative jolts in this book, also, allow others to take you somewhere else. And if you've seen them employed before, then seeing them isolated and in focus can jolt you anew.

advice: seek out a jolt from a friend.

get out of the hole

Creativity experts agree on one thing. If you're digging a hole straight down and not finding anything, don't keep digging deeper. Move over and dig a new hole.

Perhaps it's human nature to keep beating a problem, but it sure doesn't do much for you or the problem.

Here's an analogy that might clarify this point: many marital partners argue about the same issues over and over again. They

attack the issue in the same way and the issue never gets resolved. What they don't realize is that the tactics they are using to argue, discuss or figure things out are not working. Clearly, to any outsider, it would be beneficial to find a new tactic to work things out. The same is true with a design problem. If your concept isn't working, try another concept. That means developing an entirely new concept.*

advice: change course.

Point of clarification: For many, there is confusion over the difference between separate concepts and variations on one concept. Variations on one concept are not different concepts. You've created another concept when you come up with an idea that is in another direction entirely from the original concept.

go to unusual sources

Most of us look through an awards annual to jump start an idea. Of course, one never intends to copy what is in the annual, one simply uses other designers' works as eye candy or stimulation. In the process of looking at professional, recognized work, one hopes an idea may be born.

Rather than limiting yourself in that way, stay open to unusual sources. Having a creative epiphany or finding a creative approach at a twelve-tone opera or while reading Philip Roth is fruitful. At the very least, it can be motivational. Can what Amy Tan or Maya Angelou do with language be done visually? Can Mozart's weaving of voices in *The Marriage of Figaro* be done with visual textures? Does the local kitsch make you think of something visually funky?

Here's an example of going to an unusual source for inspiration or just attitude: Ayurveda, an ancient holistic system of well-being from India, involves Sattvic (pure) food, which is needed to heal and maintain good health. Pure food must incorporate six tastes in every meal: sweet, sour, salty, bitter, astringent and pungent.

To a visual communications professional, this philosophy can translate into how ingredients are combined to create a total concept. How each element complements the other is crucial to design, illustration and art direction. Reconceiving the idea of designing the whole and how each element complements the other, in this light, may force one to reinvent the idea of composition. Expand your palette of creative options.

advice: seek out a jolt, to a sudden, strong feeling of surprise from an odd source.

notice things around you

EVERYTHING COUNTS. Whether you're reading, listening to a conversation, shopping or walking down the street, notice things around you. One of the goals of critical and creative thinking is to notice the possibilities in any given situation. With myopic vision, many of us look only where we think we'll find an answer, rather than looking everywhere.

Here's a great example of being observant: A renowned British art director once said that his creative team couldn't think of a concept for a beer commercial. So they went to the local pub to think, to unwind. There was such a din of noise that whenever they opened their mouths to speak, all they could hear was the din. They used their predicament in the beer commercial:

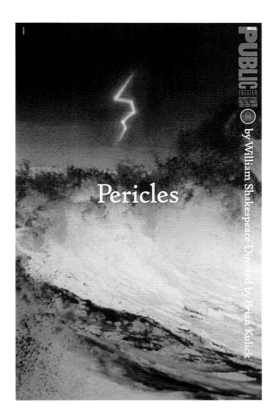

As most Broadway advertising now attempts to duplicate the bold, noisy look of the Public Theater graphics, typography in Pentagram's posters for the Public has grown quieter, to stand out in the din.

title: the public theater, *pericles*
description: poster
design studio: pentagram design/new york, ny
partner/designer: paula scher
designers: anke stohlmann, keith daigle

when the actors in the commercial opened their mouths, barroom noise came out! It was hilarious and award-winning.

Many of us put things on the back burner in order to mull them over. If you have your design problem in the back of your mind and you stay open to noticing things, chances are you'll find a solution more quickly. If you simply leave it in the back of your mind without being a keen observer, you're less likely to find an exciting solution.

advice: notice the possibilities in any given situation.

pay attention to your environment

You are where you live! Whether it is ugly, bucolic or, goodness forbid, bland, an environment can inspire. The relics and industrially designed structures of urban cityscapes, the historic buildings and houses of small towns, the textures of the seashore—all hold a plethora of visual wealth.

Gleaning elements from the environment—differently shaped fire hydrants, subway maps, quirky integrations of type and visuals from local signs, graffiti, debris, layers of posted bills, the relationship of outdoor boards to their surroundings and, yes, even the way bugs land on flowers—add to a designer's cache of visuals and can inspire ideas.

advice: travel.

carry a pineapple

Many people refuse to take risks in their work. They'll take risks drinking, driving, in sports and in love, but not in their work. Playing it safe holds some people back from taking chances in their work.

Risk appearing foolish by carrying a pineapple everywhere you go. What you'll learn is that people may laugh, stare or point. Big deal. Perhaps the experience will allow you to take risks in your work.

advice: proceed in an irregular, bumpy or jerky fashion. break out of the box.

title: *2wice magazine — night*
design studio: 2wice magazine/new york, ny
editor & designer: j. abbott miller
client: the 2wice arts foundation

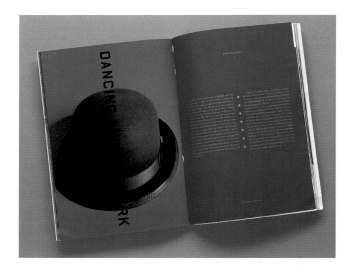

be independent

We offer three different thoughts on mimetism.

1. When a designer or creative team produces a "break-out" piece, similar ones soon follow. For example, years ago the Chiat/Day agency created a great, fresh print and television campaign for the NYNEX yellow pages based on puns. On the heels of their campaign, everyone used puns for a while. However, for a pun to work, it has to be brilliant, otherwise it sounds trite. Also, lots of commercials started to sound alike.

On the subject of imitation, Pentagram says about Paula Scher's Public Theatre posters (page 11): "As most Broadway advertising now attempts to duplicate the bold, noisy look of the Public Theater graphics, typography in Pentagram's posters for the Public has grown quieter, to stand out in the din."

2. Working from preconceived notions, and imitating what they think graphic design or advertising should look like, some people imitate the ubiquitous visual junk (the litter of poor graphic design—local ads, signage, low-end rag sheets). Big mistake. This type of mimetism is counterproductive to creative design. For example, advertising shouldn't sound like advertising. Successful advertising never sounds like a sales pitch.

When one is an independent thinker, the results can be noteworthy, as is the spread from *2wice* magazine (page 12), which has unusual juxtapositions, metallic ink on blue vellum, witty typography and a dramatic composition.

3. If you can't avoid following a school of thought, or simply imitating, then put your own spin on it. As a point of information, Rembrandt was a follower of Caravaggio. Of course, Rembrandt is considered a master. He put his own twist on the chiaroscurro style created by Caravaggio.

advice: do your own thing, or at least give it a good twist.

expand your taste by looking at great stuff

Whether you prefer to look at the work of a great, cutting-edge fashion designer, photographer or graphic designer doesn't matter. What matters is the quality of the work you immerse yourself in. Mediocrity grows from mediocrity. Greatness needs a fertile environment.

advice: indulge yourself in a jolt of a brief strong potion, visual whiskey.

use what you know in new ways

Some of us have strong drawing skills. Others have a fine sense of humor. Know your strengths and weaknesses and tap into the strengths and maybe even the weaknesses. For example, if you have good drawing skills, don't rely on photography. Draw. If you have weak drawing skills, perhaps a primitive looking drawing could be utilized for one of your concepts.

Do you have a fine art background? Can you utilize it in your graphic design or art direction? Just take a look at George Tscherny's beautiful brush work (see page 139). Do you tell great jokes or narratives? Can you create a design that's based on humor or copy? Take a look at the business card by Sandstrom Design (page 79). Jilda Morera always claims she can't draw; however, she is certainly able to draw with a camera as evidenced by the beautiful linear quality of the forms in the photograph on page 13.

advice: capitalize on what you've got!

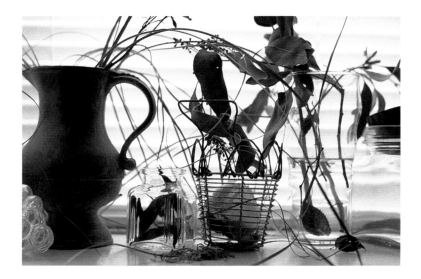

"I was stuck inside (when I lived in New York) due to snowstorm after snowstorm, with only the dreary view of a parking lot. Just a few sun rays through the kitchen window brought such a warm glow to the collection of tchotchkas on the windowsill, and I was drawn in."

title: "window sill with objects"
description: photograph
studio: jilda morera photography/palm harbor, fl
photographer: jilda morera

create a zeitgeist

Here's a new design manifesto for our time, for the twenty-first century: forget the legacy of modern art. Abandon maintaining the inherent flatness of the two-dimensional surface that our modern art forerunners sought to ensure. Abandon the generic flatness and homogenous graphics that result from using drawing and photo-editing programs. Create the illusion of three-dimensional space.

advice: deny the flat surface!

try a new doctrine on for size

"Not use a grid? Blasphemous!" we overheard at an AIGA conference. "A trendy new font—I'll never give up the classics," a designer uttered at a HOW conference.

Many of us are Bauhaus devotees. Some pray to the Swiss school. Others would never design legible typography. Although we thank goodness for all the differences, we must insist that being inflexibly attached to dogma can cause myopia.

Believing in one school of thought shouldn't disallow other influences. A different design philosophy can aid you in reinventing yourself as a designer.

Though some may not think so, some doctrines are compatible with others. One can find interesting visual relationships in a different school of thought.

advice: be flexible.

title: "callisto"
design firm: segura inc./chicago, il
art direction: carlos segura
designer: kevin grady
client: [t-26]

cross over

Blur the line between fine art and design. As Thomas Ema has said, he knew his schooling was complete when he "learned to paint with type."

Every time you create a design, you could be creating an objet d'art. Carlos Segura is a quintessential sensualist, someone who understands the plasticity of the design medium, creating both art object and mass communication simultaneously.

advice: be aware of the potential plasticity of your medium.

become

The Cubist artists, writers and philosophers had an interesting idea. Nothing is. Everything is in the process of becoming.

You evolve as a designer. With every design project, you have an opportunity to emerge as the designer you are becoming (regardless of how many years you've been in the profession). Remember, "A rose is a rose is a rose," Gertrude Stein sagaciously said.

advice: find the vital élan in yourself.

With that in mind, we'd like to remind you, dear Reader, that, when you design, you create the artifacts of our time.

We've provoked you with words. Now for the good stuff. Enjoy and fasten your seatbelt. Jolts await you.

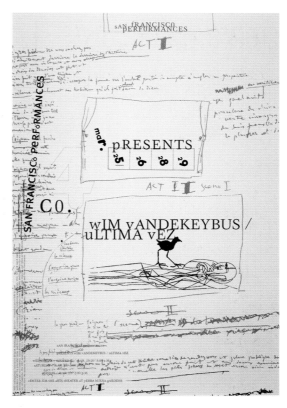

A series of posters and bus shelters designed for San Francisco Performances that announces upcoming performances by Anne Teresa de Keersmaeker/Rosas, Wim Vandekeybus/Ulltima Vez, DV8 Physical Theatre, Eiko and Koma with the Kronos Quartet and the Stephen Petronio Company. The series and performances feature quite different elements of dance and the individual posters needed to reflect the works of these various dance companies. The companies had little or no photography to work with, so the typography became responsible for evoking the dance or experience of each performance.

title: san francisco performances
description: poster
design studio: jennifer sterling design/san francisco, ca
art director/designer: jennifer sterling
illustrator: jennifer sterling
copywriter: corey weinstein

2 jolts

"look at what everyone is doing, then do something else."

betty landa, robin landa's mother

tapping into the zeitgeist

"although many meanings cluster round the word 'masterpiece,' it is above all the work of an artist of genius who has been absorbed by the spirit of the time in a way that has made his individual experiences universal."
kenneth clark

What typifies the spirit of an age? In all the arts of a particular time, there seems to be ideas and events that run true and symbolize or reflect the politics, society, ethics, cultural trends, and popular beliefs. Some artists create the zeitgeist; others reflect it.

Petrula Vrontikis's brilliance as a designer is manifested in many ways (see page 19). One way is her ability to draw from unusual sources, tap into history, yet transmit the zeitgeist in her work. Her color palette, typography and composition all speak to the present moment; we can feel the essence of her subject as well as our contemporary time period.

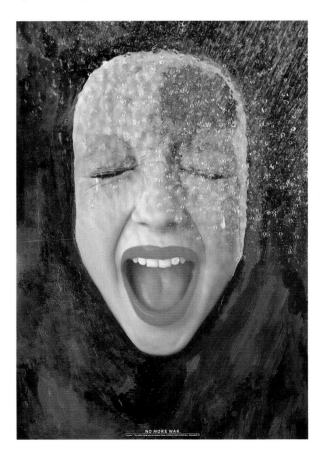

This is the poster for the Japan Graphic Designers Association Inc. (JAGDA) Peace and Environment Poster Exhibition, Hiroshima-Nagasaki.

title: "no more war"
description: poster
art director/designer/illustrator: kenzo izutani
additional designer: aki hirai
design studio: kenzo izutani office corporation/tokyo, japan
photographer: yasuyuki amazutsumi
client: jagda

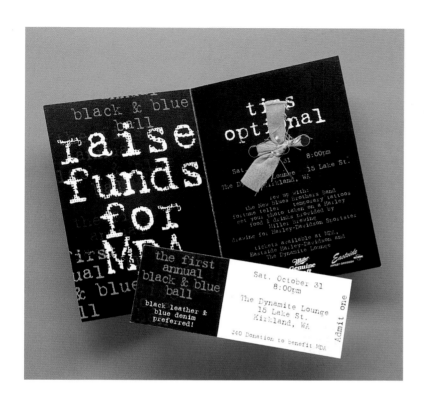

An invitation for a fundraising event for Harley Davidson riders utilizes a bold "in-your-face" headline which pays off inside to tug at the heartstrings of even the toughest, meanest hombres. Strips of blue bandanas reinforce the notion that although this is a black and blue "ball," it sure ain't black tie.

title: black and blue ball invitation
design studio: art-o-mat design/seattle, wa
designers: mark kaufman, jacki mccarthy
copywriters: mark kaufman, jacki mccarthy, jane emery
client: muscular dystrophy association

"Children First *is a book containing images and writings as a celebration of children donated by the top fashion photographers and recordings of children-related music from top recording artists,*" explains Petrula Vrontikis. "*The challenge was to emotionally sequence the images for maximum impact. I could not crop or manipulate color in any of the images. This opened up more possibilities in experimenting with juxtaposition and scale to support the narrative. All proceeds of the sale are donated to Homes for the Homeless, an organization assisting homeless kids and families.*"

title: children first
design studio: vrontikis design office/los angeles, ca
designer: petrula vrontikis

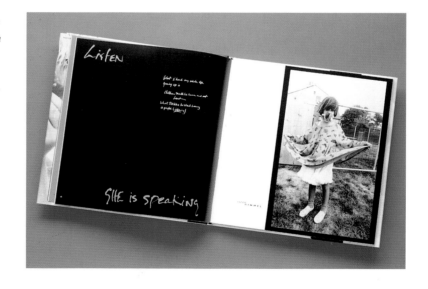

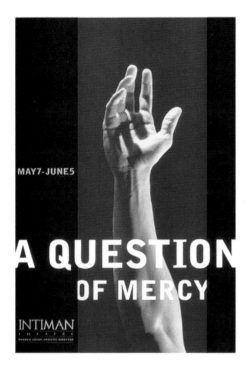

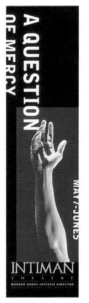

Poster and bookmark design for a play about assisted suicide for a man with AIDS.

title: *a question of mercy*
design studio: the traver company/seattle, wa
designer/typographer: christopher downs
photographer: jimmy malecki
client: intiman theatre/seattle, wa

Poster and DM pieces for a play about riots and race relations in Brooklyn, New York, in the summer of 1991.

title: *fires in the mirror*
design studio: the traver company/seattle, wa
designer/typographer: christopher downs
client: intiman theatre/seattle, wa

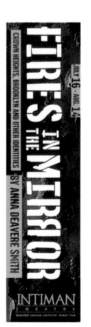

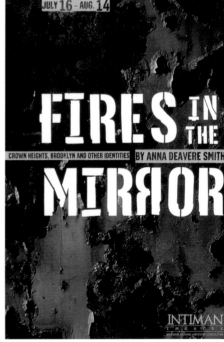

title: "afterburn" and "random acts 2"
description: posters
design firm: segura inc./chicago, il
designer: carlos segura
illustrator: eric dinyer
client: waxtrax records

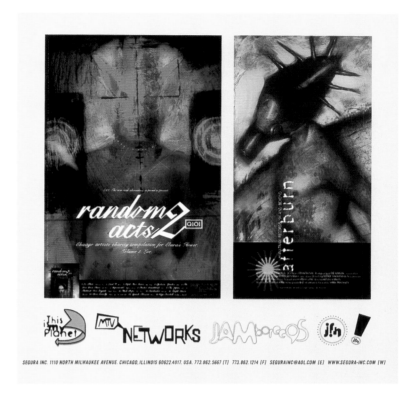

title: *whereishere* spread
design studio: sagmeister inc./new york, ny
concept & design: stefan sagmeister
photographer: tom schierlitz
illustrator: kevin murphy

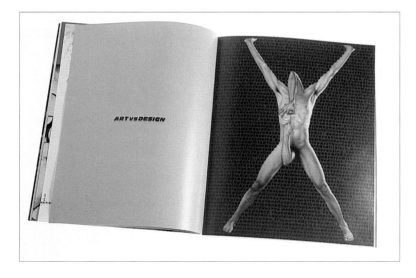

media and techniques

"practically all great artists accept the influence of others. but...the artist with vision sees his material, chooses, changes, and by integrating what he has learned with his own experiences, finally molds something distinctly personal."

romare bearden

Thinking of printing as an integral part of a design project allows for printing to be part of the design concept. For example, Stefan Sagmeister's design concept for the CD cover, *Technodon*, utilizes the jewel case packaging in an atypical and surprising way (page 24).

Due to the recent advantage of the computer as a tool, many have moved away from traditional techniques, including fine art techniques, such as printmaking and three-dimensional constructions—or more primitive ones, such as rubbings, blottings or even using Silly Putty to transfer or distort an image. Steve Brower constructed a distressed-looking American flag as a play on the book title and to convey the meaning of *Sam Smith's Great American Political Repair Manual* (page 24).

Cadence feels different about technology than other companies because they benefit from it getting too complicated. As electronics become smaller and more difficult to design, Cadence's business grows. The irony of this situation is captured on the cover and opening pages of the report. A great year for Cadence is when companies are in over their heads and the process gets too complicated for customers to handle on their own. To validate this message, customer stories are highlighted in the report. Several different styles of illustration and photography are placed next to each other to suggest the wide range of products that utilize Cadence technology.

title: cadence annual report
design studio: cahan & associates/san francisco, ca
art director: bill cahan
designer: bob dinetz
client: cadence

Most venture capital firms are perceived as "vulture capitalists"—only out for money. InterWest Partners, however, are known for being the "nice guys" of the business. Instead of bragging about their hefty capital resources or their long list of credentials, the thrust of this piece is on their keen ability to create and maintain relationships. Large headlines are the objective voice of a therapist giving advice about successful relationships. Small quotes from the partners support the therapist's ideas with more specific business language. Small line-art illustrations and short first-person biographical statements further differentiate the client's approach from the slick ones of most venture capital brochures. The entire brochure is letterpressed on French-folded paper to give it a personal, intimate feel.

title: interwest partners brochure
design studio: cahan & associates/san francisco, ca
art director: bill cahan
designer: kevin roberson
client: interwest partners

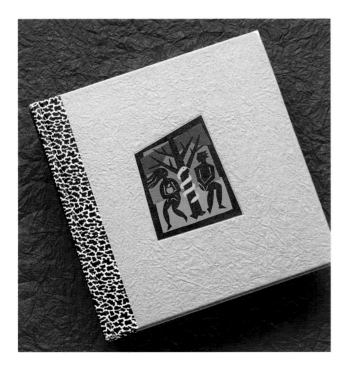

The Diaries of Adam & Eve by Mark Twain is one in a series of limited-edition books produced by Heritage Press. It is a charming chronicle of Mark Twain's discovery of true love and devotion. The design was approached to evoke the same playful attitude as the author's writing. The book's dimensions, six inches square, mimics the small size of a real diary. The text is accented with gatefold spreads that have intricate laser die-cut icons of Garden of Eden imagery. These pages fold open to reveal colorful illustrations of Adam and Eve done in a casual cut-paper style. Throughout the design are more references to Eden. A snakeskin pattern is silk-screened on the binding tape of the cover. The flysheet consists of a handmade paper containing actual pressed leaves, butterflies and flowers.

title: *the diaries of adam & eve*
description: special edition of mark twain's *the diaries of adam & eve* produced by heritage press
design studio: sibley peteet design/dallas, tx
designers/illustrators: don sibley, rex peteet

This CD cover for Ryuichi Sakamoto & YMO, titled Technodon, includes ten different covers. It is up to the consumer to choose his/her favorite front cover. Each cover contains coded typography by American artist Jenny Holzer. This type is only readable when the card is put back into the plastic jewel case.

title: ryuichi sakamoto & ymo, *technodon*
description: cd package
design studio: sagmeister inc./new york, ny
creative director: tibor kalman
concept & design: stefan sagmeister
coded typography: jenny holzer
photographer: ed lachman/stock
client: toshiba/emi

"I painted and aged this piece of wood in my garage," says Steven Brower. *"I then brought it to Home Depot to have it sawed apart. One of the friendly salespeople in the lumber department did so happily. Another one stated that doing this to the flag is illegal and wanted no part of the whole affair."*

title: *sam smith's great american repair manual*
description: jacket for nonfiction political book
design studio: steven brower design/new york, ny
art & designer: steven brower
photographer: arnold katz
client: w.w. norton

SAM SMITH'S GREAT AMERICAN POLITICAL Repair MANUAL

How to rebuild our country so the politics aren't broken and politicians aren't fixed!

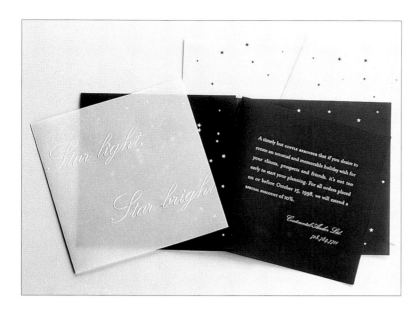

Designed, engraved and embossed by Continental-Anchor Ltd. on Cromática Extra White and Indigo.

title: "star light, star bright"
description: holiday promotion piece
design studio: continental-anchor ltd./long island city, ny
designer: continental-anchor ltd.

A new mailer by Sayles Graphic Design puts the pieces together for Drake University students participating in Greek "rush"—fraternity and sorority membership. Using the theme "Be a Part of It," the brochure's double-ply chipboard cover is die cut in the shape of a puzzle piece. Affixed to the chipboard are imprinted "parts"—hammered aluminum, label stock and manila tags—each bearing a word of the brochure's title.

Inside the piece, a variety of printing and finishing techniques are used, including thermography, embossing, die cutting and offset printing. Hand-applied glassine envelopes contain additional information. The brochure is bound with wire-o-binding and an aluminum ring. Two colors of T-shirts were printed with coordinating graphics for counselors and members. The earthy colors reflect the brochure's design.

"In addition to effectively portraying the theme, 'Be a Part of It,' says designer John Sayles, "the mailer engages readers and encourages them to focus on the information it contains."

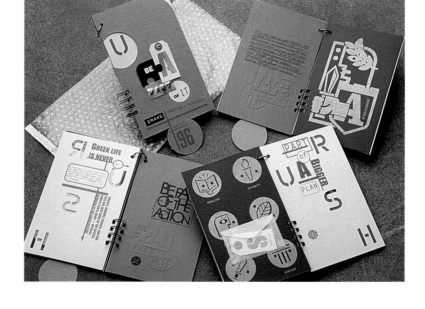

title: "be a part of it"
design studio: sayles graphic design/des moines, ia
art director/designer/illustrator: john sayles
copywriter: kristin lennert
client: drake university/des moines, ia

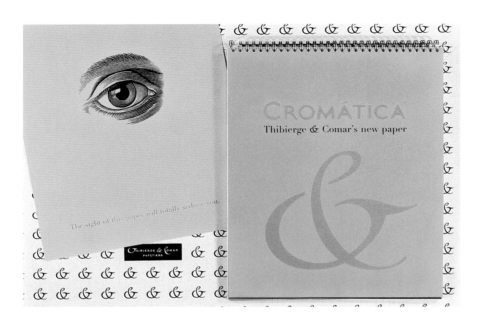

Presentation brochure of Cromática-colored natural translucent paper.

title: chromática brochure
design studio: thibierge & comar papetiers/
paris, france

Press release/crystal line on Cromática paper. Printed by Edition Speciale-Paris.

title: baccarat press release
design studio: thibierge & comar papetiers/
paris, france

title: *strange bedfellows* cover image
design firm: capitol records/hollywood, ca
art directors/designers: tommy steele,
george mimnaugh
photographer: larry dupont
client: capitol records/hollywood, ca

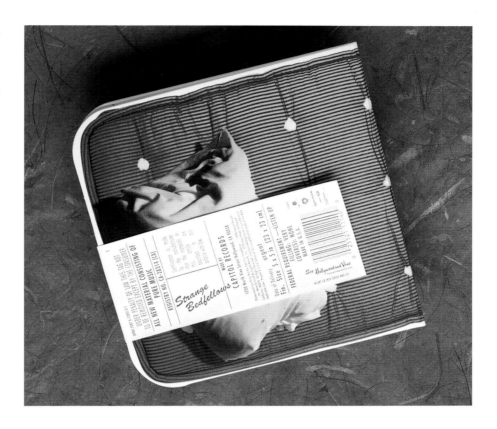

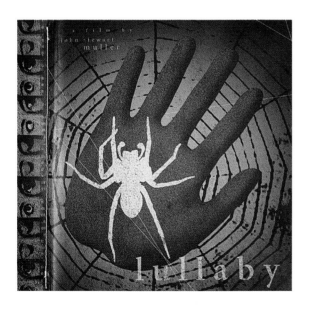

A press kit created on a very small budget, it was printed in-house on a large-format color printer on a single sheet of stock (both sides), then hand assembled and stitched.

title: *lullaby* press kit
design studio: muller + co./kansas city, mo
creative director: john muller
art director/designer: jane huskey

visual metaphors

my love is a rose. through the identity of a rose we understand love; we allude to all the characteristics of that object: that it is delicate, soft, sweet-smelling; it blooms, yet has thorns.

"A metaphor states an identity," says Dr. Richard Nochimson, English professor at Yeshiva University. A metaphor makes comparisons between emotions and objects or between ideas and objects; points out similarities but states the similarities in terms of an identity in order to make a strong statement.

Using metaphors allows you to communicate things more dramatically or delicately. It pictorially guides the viewer to a particular meaning set.

In advertising, a visual metaphor seduces the viewer and doesn't scream, "I'm an ad and I'm trying to sell you a product." Successfully employing a visual metaphor in graphic design can carry visual communications into the realm of poetry.

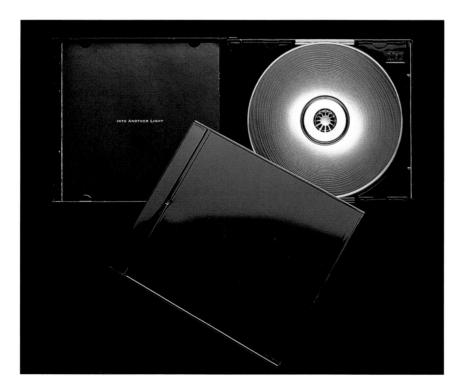

Sonny Sharrock had just died; this is his last recording, titled Into Another Light.

No explanation necessary.

title: sonny sharrock, *into another light*
design studio: sagmeister inc./new york, ny
designers: stefan sagmeister, veronica oh
photographer: adam fuss
client: enemy records

Each year, Progressive commissions an artist or a group of artists to create a body of work for their annual report, which is inspired by a Progressive theme. This year, the inspiration was the American passion for car travel and the culture born from it. The artist is photographer Stephen Frailey. Stephen works by collaging found images to create new meaning from their juxtaposition. Frailey's work will become part of Progressive's growing collection of contemporary art.

title: the progressive corporation annual report
design studio: nesnadny + schwartz/
cleveland, oh
art directors: mark schwartz, joyce nesnadny
designers: joyce nesnadny, michelle moehler
artist: stephen frailey
copywriters: peter b. lewis,
the progressive corporation
client: the progressive corporation
The Tree Design is a federally registered trademark owned by Julius Saman, Ltd., and is used here with permission.

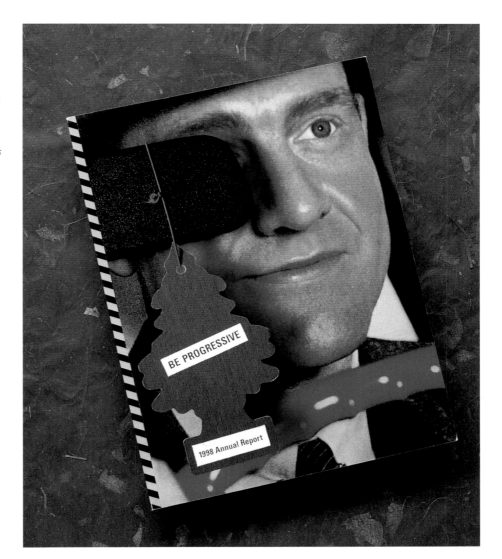

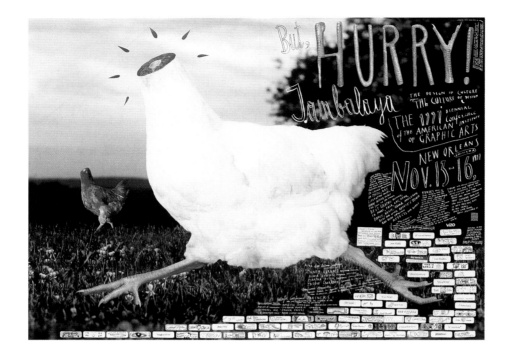

As it reads in tiny squiggly type on the top corner of this poster for the National Conference of the American Institute of Graphic Arts: "Why a headless chicken? Is it a metaphor for the profession? Should we stop running around like one and sign up for this very interesting conference? Is it a Voodoo symbol? Anti-technology? Will a mixture of telephone scribbles and turn of the century Art Brut really be the hot new style replacing wood veneer, itsy-bitsy type in boxes and round corners? Wasn't the New Simplicity supposed to come first? Euro-Techno?"

title: aiga new orleans jambalaya
description: poster
design studio: sagmeister inc./new york, ny
art director/designer: stefan sagmeister
photographer: bela borsodi
illustrator: stefan sagmeister
paint box: dalton portella/magic graphics, inc.
additional illustration: peggy chuang, kazumi matsumoto, raphael rüdisser
client: aiga

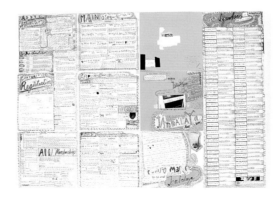

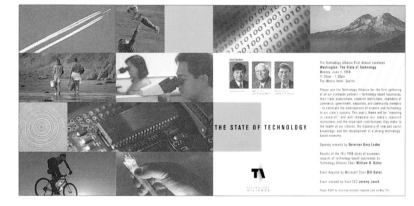

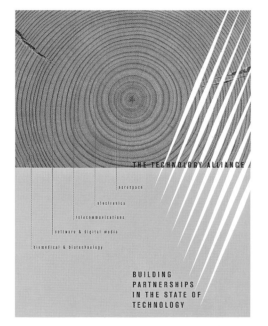

The Technology Alliance is a consortium of technology-based businesses in Washington state. The information brochure and announcement employ an icon of an old industry that was once the main economic engine of the region. Using an image of a tree ring and a faux timeline proposes to show that technology industries are the new driving force of the economy. Additionally, juxtaposed images of technology and lifestyle issues play up the fact that the future relies on these new industries.

title: technology alliance
description: information materials
design studio: art-o-mat design/seattle, wa
designers: mark kaufman, jacki mccarthy
photography: photodisc
client: technology alliance

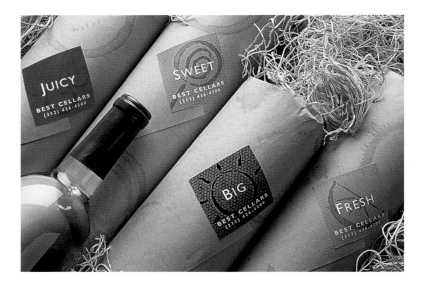

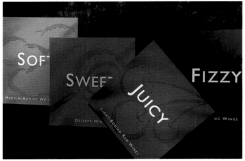

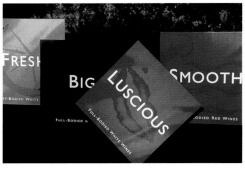

The identity for Best Cellars, a New York wine distributor and reseller, was created as a brand for the client's first flagship store. They needed an identity that would stand out among their competitors and leave a memorable impression in the minds of their patrons. The intended audience consisted of a mixed clientele, everyone from connoisseurs to novices looking for the high-quality, yet economic ten-dollar-and-less inventory.

The objective was to convey affordability without compromising taste through a minimalist presentation. As a result, an unpretentious identity was designed using the concept of a wine stain—the ring that occurs when red wine has been poured and the bottle placed on a white tablecloth after wine has spilled down the side of the bottle. This shape defines the "C" of the Cellars. The typographic treatment of the "B" complements the roughness of the stain. A series of metaphoric icons was also developed, again using the basic wine stain, to support the identity and to identify eight different categories of wine: Luscious, Fizzy, Juicy, Sweet, Fresh, Big, Smooth and Soft. Each icon related to the descriptor: lips for Luscious, bubbles for Fizzy, cherries for Juicy, a lollipop for Sweet, a lemon wedge for Fresh, the sun for Big, water and the moon for Smooth and clouds for Soft. The icon graphics were expanded to include a set of thirty-inch-square signs—output as Iris prints and mounted on wooden panels—which were used to categorize the selections. These signs were also reduced to label size and applied to kraft paper used by Best Cellars to wrap a bottle of wine after purchase. This identity was applied to a stationery program (made from kraft stock and two-color application), stickers (made with two colors each), wine bottle-carrier packaging (made from kraft box stock and one-color application) and in-store graphics/posters (which are Iris outputs in quantities of one each for in-store display).

title: best cellars
description: in-store posters
design studio: hornall anderson design works/seattle, wa
art director: jack anderson
designers: jack anderson, lisa cerveny, jana wilson esser, nicole bloss
illustrators: jana wilson esser, nicole bloss
client: best cellars

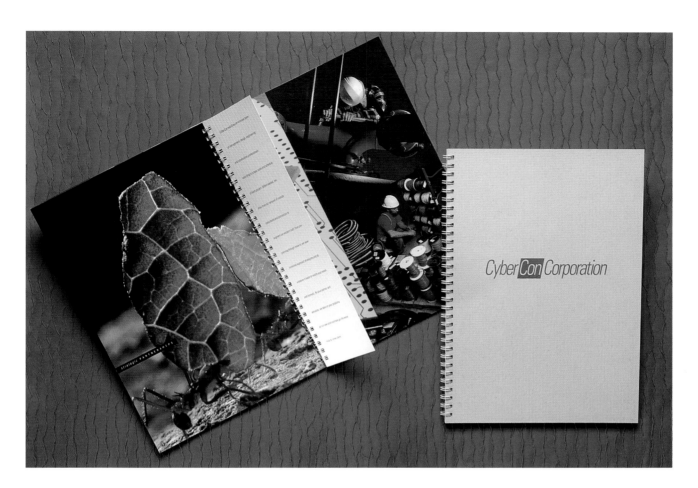

title: cyber con corporation booklet
design studio: ema design/denver, co

atypical points of view

Down with frontal views! Enough of seeing things from an average height and central viewpoint!

Seeing something from an atypical point of view—whether it is from an extreme angle, through a fish-eye lens, or from far below—allows us to see something anew.

Even super-familiar objects can look interesting and new when seen from an atypical point of view. Captured from below and composed asymmetrically in the picture format, the image of the Eiffel Tower by Bill Leith (page 37) appears in abstraction; presented as a horizontal system of crisscrossing lines rather than its usual vertical form, the famous tower looks altogether new and unique.

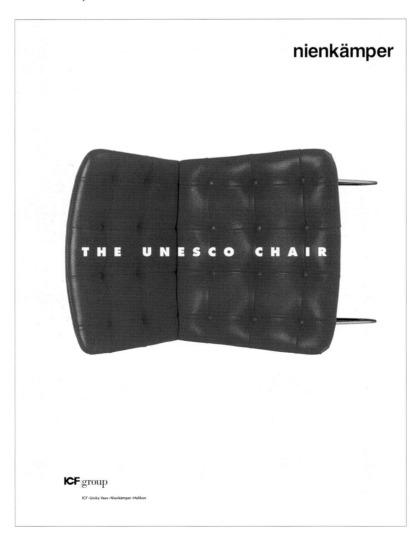

nienkämper

THE UNESCO CHAIR

ICF group

ICF·Unika Vaev·Nienkämper·Helikon

The Unesco brochure was designed to help reintroduce the Unesco chair to the contract furniture marketplace. The images are given ample white space to allow for a clean and clear look. This treatment of the images allows the clean design of the chair to speak for itself.

title: the unesco brochure
design studio: teikna graphic design, inc./
toronto, ontario, canada
designer: claudia neri
photographer: evan dion
copywriter: pamela young

"Even with overworked subjects like flowers, my point of view is less horticultural and more of the human experience," explains George Tscherny.

title: calendar
design studio: george tscherny inc./new york, ny
designer: george tscherny
client: sandy alexander, inc.

title: "from my window"
design studio: steven bleicher/ft. lauderdale, fl
illustrator: steven bleicher

"All of my artwork is very process oriented," says Steven Bleicher. "I always start out by obtaining my own images or creating them from scratch. When using photographs, I prefer to shoot all of my own images and rarely hire a photographer. I have never used stock photography because I believe that in order to have the final artwork come closest to my original vision, I have to be the one to capture the initial image.

"The next step when using photographs is to manipulate the image in some fashion. I have used Polaroid transfers, SX 70 manipulations and for the last ten years, a computer. I work in either Photoshop or Painter exclusively.

"After manipulating the image by any of the above processes, I transfer the image to canvas, continuing to work on the image with oil paints to develop a rich painterly surface. The image can then be either rescanned for a final output or presented in its final state. This last part is totally dependent upon what the final piece will be used for, either a mass-produced illustration or as an original fine art creation."

title: "church #8"
design studio: steven bleicher/ft. lauderdale, fl
illustrator: steven bleicher

This is a poster for CHARLE. CHARLE is a lounge-wear/underwear company.

title: "mirror of self"
design studio: kenzo izutani office corporation/ tokyo, japan
art director: kenzo izutani
designers: kenzo izutani, aki hirai
photographer: zigen
client: charle co., ltd.

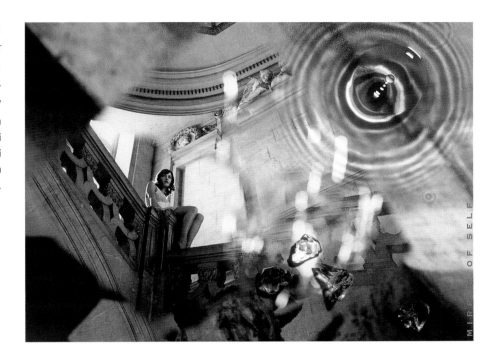

title: "eiffel tower no. 2"
description: color photograph
photographer: william leith/bethesda, md

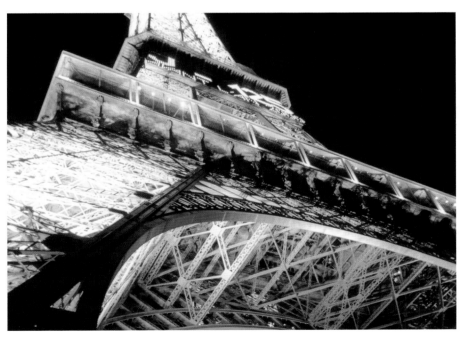

"I was very excited by this children's book project," says Yvonne Buchanan. "I longed to reinterpret history, to gather black-and-white photographic reference and bring it into my own Technicolor world. My style is the use of a free, expressive line, supported by almost unrealistic, high-key color. I love blues, turquioses, navy blues, cobalts. When we think of the past, we almost always think about sepia tones and a faded color scheme; however, there was a colorful range of patterns and fabrics. The sky and the land has always been as brilliant as it is now, and I wanted to show that."

title: "looking to fly"
description: illustration from the book,
fly, bessie, fly by lynn joseph
design studio: buchanan illustration/brooklyn, ny
art director: lucille chomowicz/simon & schuster
editor: andrea pinkney
illustrator: yvonne buchanan
Published by Simon & Schuster Books for Young
Readers.

Art for Fly, Bessie, Fly, *a children's book.*

title: "bessie coleman in texas"
description: illustration from the book,
fly, bessie, fly by lynn joseph
art director: lucille chomowicz/simon & schuster
editor: andrea pinkney
illustrator: yvonne buchanan
Published by Simon & Schuster Books for Young Readers.

fantasy and surrealism

"a designer...has the responsibility to give his audiences not what they think they will want, for this is almost invariably the usual, the accustomed, the obvious and, hence, the unspontaneous. rather, he should provide that quality of thought and intuition which rejects the ineffectual commonplace for effectual originality."
lester beall

Whether they stem from dreams or invention, it's hard to ignore the haunting images of fantasy and surrealism. Fantasy, art that is characterized by dreamlike, fanciful imagery, and Surrealism—art that attempts to express the workings of the unconscious and subconscious mind with highly capricious, irrational or supernatural imagery—seem to appeal to the psyche on a primordial level.

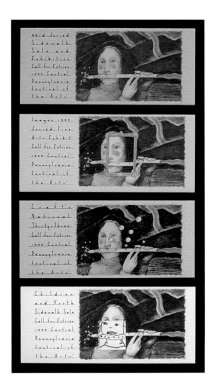

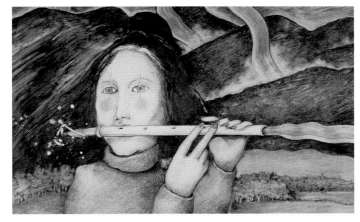

The annual summer event is a celebration of the visual and performing arts. The clown/jester was used as a metaphor for performance, entertainment, etc. The flute she is playing is also an artist's brush with paint splashing off it (visual arts). Out of the other end of the flute is spurting a rainbow (music, creativity, etc.) that is echoing through a mountainous countryside similar to the area where the festival is held.

title: central pennsylvania festival of the arts
description: poster and brochure
design studio: sommese design/state college, pa
art director/illustrator: lanny sommese
designer: abbey kuster
client: central pennsylvania festival of the arts

André Breton, in his 1924 *Manifesto of Surrealism*, stated: "Surrealism. Noun, masculine. Pure psychic automatism, by which one intends to express verbally, in writing or by any other method, the real functioning of the mind. Dictation by thought, in the absence of any control excised by reason, and beyond any esthetic or moral preoccupation."

As an archetypal dream drama is played out in David Wheeler's illustration (page 40), we see the surrealistic allusion.

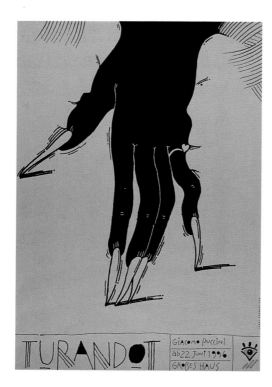

The image was created to reflect the nature of the opera written by Giacomo Puccini, which is a dark comedy set in China. The princess Turandot has her suitors killed if she rejects them as her husband. The contour lines that form the suitors' heads are also the edge of the dark female hand with very long fingernails (very fashionable amongst the Chinese elite). The nails also make the hand look evil and relate it directly to the content of the play.

title: *turandot*
description: theater poster
design studio: sommese design/state college, pa
art director: lanny sommese
designer: lanny sommese
illustrator: lanny sommese
client: volkes theatre/rostock, germany

Illustration for an article about school expulsion for off-campus crimes.

title: "long arm of the school"
design studio: david wheeler/lynnwood, wa
art director: jennifer levin
designer: david wheeler

Man sitting inside The New York Times Book Review *section.*

title: "can't steer from the back seat of life"
description: *the new york times book review* section
design studio: fedorova dezign/new york, ny
art director: steven heller
designer: ivetta fedorova
client: *the new york times*

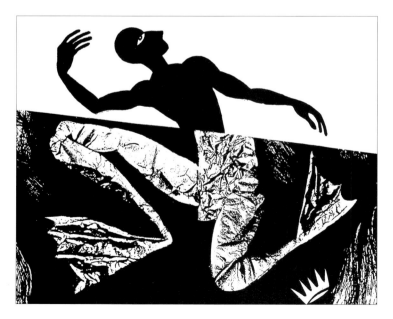

This is a story about a man who dreamt of being a ballet dancer and wanted to dance a solo as the prince in Swan Lake, *but he had flat feet and had no real talent for dancing. Instead he became a teacher and learned to appreciate his life for what it was.*

title: "frog man"
description: *the new york times book review* section
design studio: fedorova dezign/new york, ny
art director: steven heller
designer: ivetta fedorova
client: *the new york times*

This illustration accompanies an article with advice on how to attract clients to their Web sites.

title: piece for *success* magazine (unpublished)
description: illustration
design studio: fedorova dezign/new york, ny
designer: ivetta fedorova
client: *success* magazine

Illustration for a story about a woman who gives tips to people on how to improve their gardens right before their guests are about to show up.

title: *washington post* "home" section
design studio: fedorova dezign/new york, ny
art director: alisse kresse
designer: ivetta fedorova
client: *washington post*

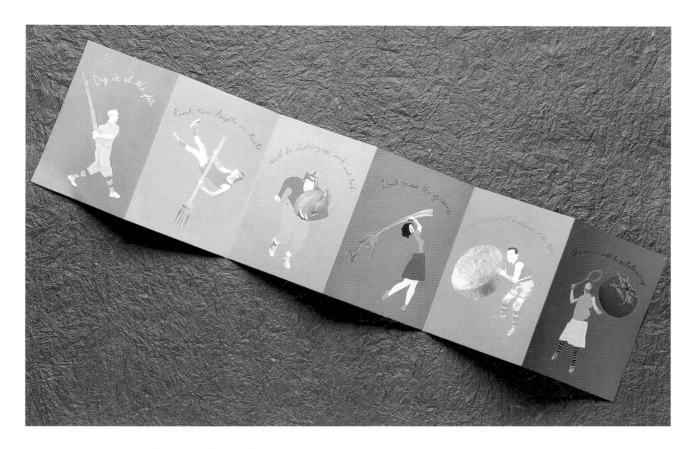

An invitation to a gourmet gala that featured sport celebrity chefs and benefitted the March of Dimes.

title: "seasoned opener" gourmet gala
description: invitation
design studio: muller + co./kansas city, mo
creative director/writer: david marks
designer: jeff miller
writer: jeff sobul
client: march of dimes

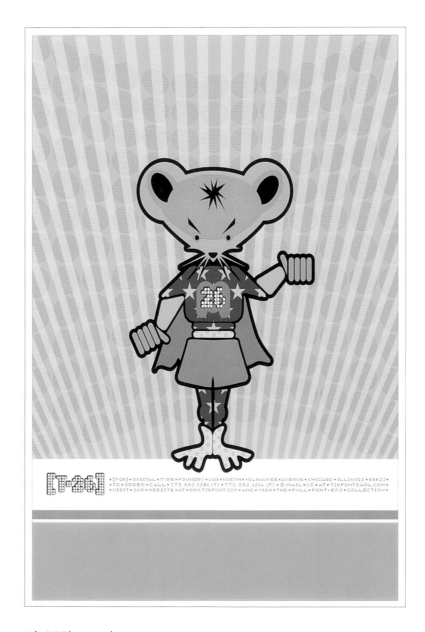

title: [t-26] logo postcard
design studio: segura inc./chicago, il
designer: carlos segura
client: [t-26]

syntheses and merges

"if at first the idea is not absurd, then there is no hope for it."
albert einstein

A well-done synthesis or merge makes you look twice. In visual communications land, where the audience barely gives graphic communication a two-second glance, that is saying a lot. Bringing similar or unlike things together and combining them into a synergistic whole can yield compelling visual results.

The key to creating a successful merge or synthesis is to find a way that the different visual parts meld, fit or melt together to create a seamless new thing. Lanny Sommese is a master at getting things to fit together perfectly, as if they were born that way (see page 47).

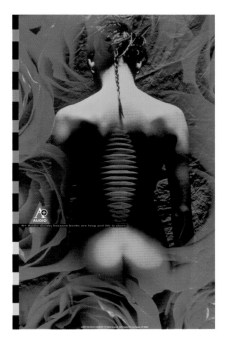
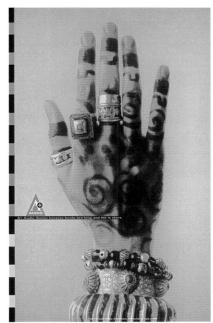
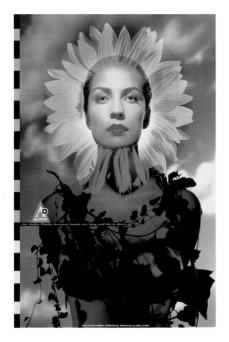

Poster series for A+ Audio, a division of Time Warner Audio Entertainment, used to advertise abridged audiotape recordings of the written classics, which include study guides. Examples shown are for Macbeth, Rite of Spring, *and* One Hundred Years of Solitude. *The product is positioned as a sophisticated* Cliff Notes *geared toward college students. The design challenge was to bring a modern movie poster/album cover look to the posters. The photographer, Scott Morgan, was able to capture the essence of the story in a modern and intriguing way.*

title: time warner poster series
design studio: vrontikis design office/los angeles, ca
art director: petrula vrontikis
designer: kim sage
photographer: scott morgan
client: time warner

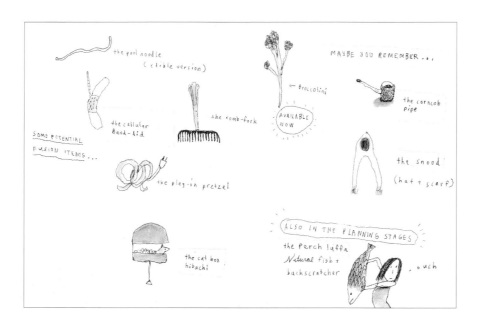

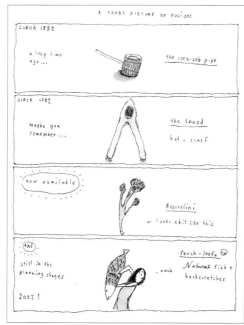

toothbrush
cigarette holder

"I am interested in inventions both failed and successful," says Jason Logan. "I.D. (International), a magazine I highly recommend, ran a short piece about the broccolini last year. This got me thinking about other 'fusion' items like Prada formal/sport shoe hybrids and fusion food restaurants. I pitched the idea to Nicholas Blechman at the New York Times and came up with this OpArt piece."

title: "better than cold fusion"
design studio: jason logan/toronto, ontario, canada
illustrator: jason logan

"Aquatics and Exotics" pet shop image was inspired by some Eskimo images the designer, Lanny Sommese, had seen. The logo was developed from them.

title: "frog/fish"
design studio: sommese design/state college, pa
art director: lanny sommese
designer: lanny sommese
illustrator: lanny sommese

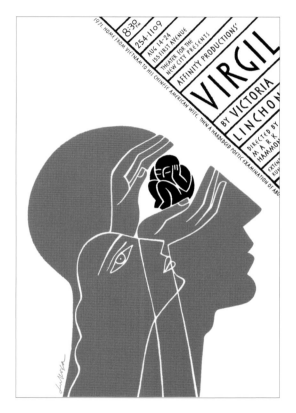

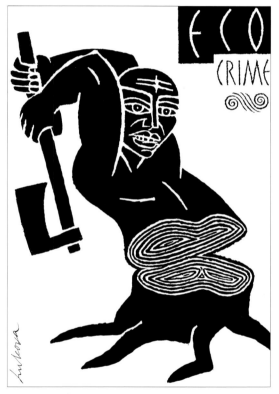

A poster for a production at the Theater for the New City, New York, directed by Mark Hammond. This is the story of a Vietnam veteran who looks at his past through the eyes of his Chinese-American wife.

title: *virgil*
description: silkscreen poster, 27" x 39"
design studio: luba lukova studio/astoria, ny
designer: luba lukova
illustrator: luba lukova

"These posters belong to the 'Crime' series—a collection of four posters originally designed for Nozone," says Luba Lukova. "The budget for this project was very limited, but to me it was a challenge to create eloquent impacting images using only one color. The series won awards from many design competitions including the Triennale of Political Poster, Mons, Belgium; World's Most Memorable Poster Show, Paris; and the International Poster Exhibition, Fort Collins, Colorado."

title: "eco crime"
description: poster
design studio: luba lukova studio/astoria, ny
designer: luba lukova
illustrator: luba lukova

The Bell Press poster was developed to emulate a style not commonly utilized by printers, that of the Cassandra era. The overlapping of the various elements are themselves the elements that distinguish this period of design. The use and treatment of the sans serif font also work to distinguish this piece in the market.

title: bell press eye
description: poster
design studio: dbd international, ltd./menomonie, wi
art director/designer/illustrator/lettering/copy:
david brier
client: bell press

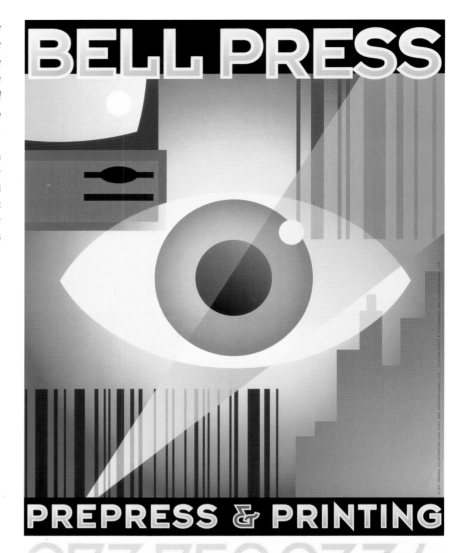

Call for the best in prepress and printing. If you don't have your "Bell Press Guide to Scitex Prepress," give us a call to get your own copy.

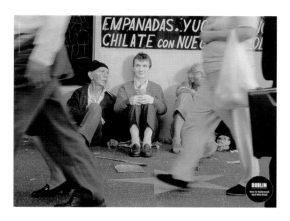
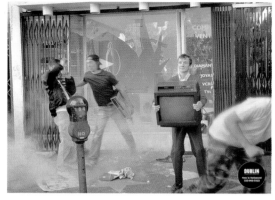
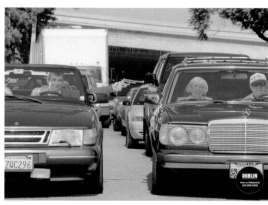
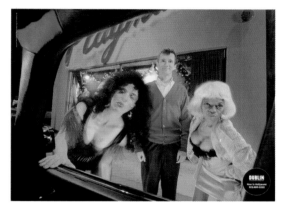
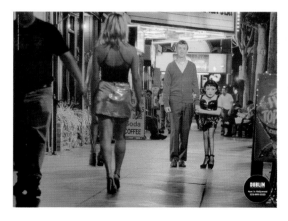
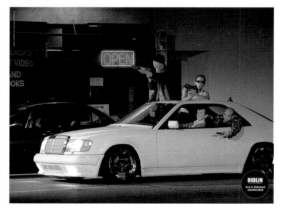

title: dublin hollywood: "drunks," "riot," "traffic," "hookers,"
"dominatrix," "gang"
description: print ad campaign
design studio: hunt adkins/minneapolis, mn
art director: steve mitchell

copywriter: doug adkins
photographer: rick dublin

unusual color palettes

"artists can color the sky red because they know it's blue. those of us who aren't artists must color things the way they really are or people might think we're stupid."
jules feiffer

Color is, at once, the most illusive of all design elements. We seem to respond to color, more than to line, shape, or composition, on an emotional, gut level.

Some designers choose trendy palettes. Some prefer limited palettes. Others follow traditional color symbolism, while some view color as idiosyncratic and personal.

Through unusual earth tones and muted colors Nesnady + Schwartz communicates warmth and charity for the annual report for the George Gund Foundation (see page 53).

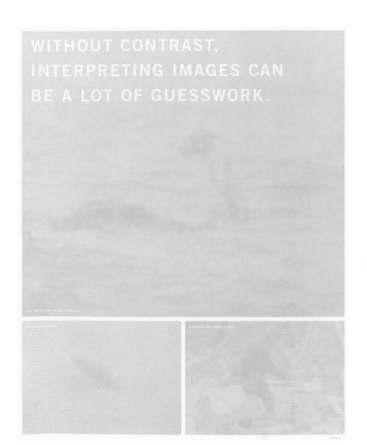

WITHOUT CONTRAST, INTERPRETING IMAGES CAN BE A LOT OF GUESSWORK.

A substantial portion of ultrasound images are unfit to be diagnosed due to poor contrast. Molecular Biosystems has created an in vivo contrast agent that dramatically increases readability and clarity of ultrasound images. In order to capture the importance of this significant development, a series of murky photographs are presented with questions asking the reader to identify and "diagnose" each picture's content. Obviously, these questions are very difficult to answer. This quiz-like exercise is analogous to the cardiologist's predicament of making accurate diagnoses without clear images.

title: molecular biosystems annual report
design studio: cahan & associates/san francisco, ca
art director: bill cahan
designer: kevin roberson
client: molecular biosystems

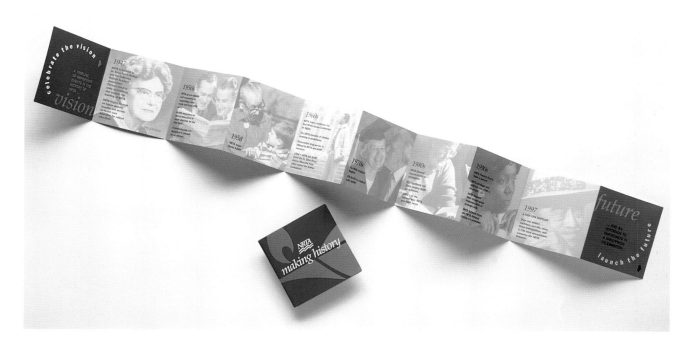

"When the National Retired Teachers Association began planning to celebrate their fiftieth anniversary, they needed a design that gave a sense of the past without looking dated, explained current activities and provided an inspirational look toward the future," says Rebecca Dixon. "I searched for an image that would tie together a group of forty products, paying homage to the continuity of past, present and future. I found the blurred but original NRTA logo reproduced as a pattern on the endpapers of a little torn book. In the middle of the logo was a lamp of knowledge; it became the central image for the new logo, where smoke spells out the theme, 'celebrate the vision/launch the future.' This accordion-fold brochure had several purposes: to give historical information 'sound bites' in timeline form (when read in one direction), and to announce awards, community service events and a convocation (when flipped over)."

title: nrta 50th anniversary
design studio: aarp creative services/ washington, dc
designer: rebecca dixon

This is the company brochure for AT&T Jens, a telephone and communications company.

title: at&t jens pamphlet
design studio: kenzo izutani office corporation/tokyo, japan
art director: kenzo izutani
designers: kenzo izutani, aki hirai
copywriter: goro aoyama
client: at&t jens co., ltd.

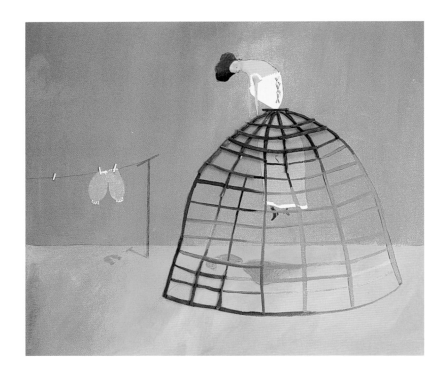

title: "cage dress"
design studio: david wheeler/
lynnwood, wa
illustrator: david wheeler

"I wanted to present jazz as a cool, more controlled music, but having Bessie be an almost vibrating element in the place—all the men are noticing her," explains Yvonne Buchanan. "I used ultramarine and turquoise for the background figures; I added lemon yellow, orange and vermilion red for the central figures."

title: "bessie in jazz club"
description: illustration from the book *fly, bessie, fly*
by lynn joseph
design studio: buchanan illustration/brooklyn, ny
art director: lucille chomovicz/simon & schuster
editor: andrea pinkney
illustrator: yvonne buchanan
Published by Simon & Schuster Books for Young Readers.

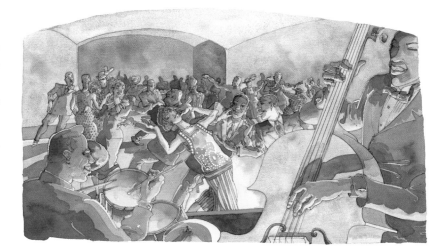

The images in this report, which so potently capture the students at the Cleveland School of the Arts, were created by photographer Larry Fink. Fink is best known for his powerful and beautiful images, which focus on the social documentation of public and private gatherings. The Foundation commissioned these photographs as a reflection of its commitment to the children of the Cleveland Public Schools.

title: the george gund foundation annual report
design studio: nesnadny + schwartz/cleveland, oh
creative director: mark schwartz
designer: michelle moehler
photographer: larry fink
copywriters: david bergholz, deena epstein

title: "desert plate"
design studio: jilda morera photography/
palm harbor, fl
photographer: jilda morera

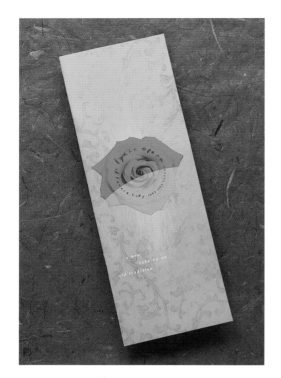

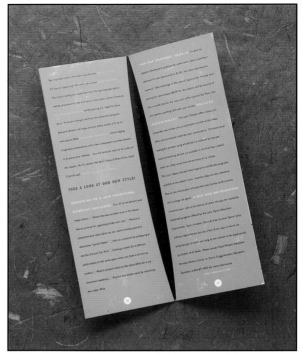

The designer used his interpretation of the individual operas to create original art for the brochure.

title: lyric opera season brochure
design studio: muller + co./kansas city, mo
creative director: john muller
art director/designer: jeff miller

historical references

"possibly the art of today has little aesthetic value, but anyone who sees in it nothing but a caprice can be sure he has understood neither the new art nor the old."
jose ortega y gasset

If you don't study the history of art and design, then you are a lost design soul. As our art history professors used to say, "We stand on the shoulders of all artists who came before us!"

Borrowing cave-painting imagery, Louey/Rubino adds historical scope to its marketing piece (see page 56).

After years of employing the same logo and glossy collateral materials, U.S. Cigar approached Hornall with the need for a new, refined brand identity and corporate materials. The logo evolved into a shape reminiscent of a cigar band, as well as the contour of an old-fashioned cigar ashtray. Since the original corporate system retained a slick appearance, the client requested a shift to textures and colors "from the earth." The distributorship binder, product brochures and capabilities brochure incorporate a rich color palette that reflects the tobacco itself. Even the binder cover and product inserts within the binder depict different "lifestyles" or "personalities" through illustrations, color and typography, which all merge together to paint a picture of the typical procurer of each distinct brand. Each piece contains a hint of nostalgia, such as retro patterns from the inside of cigar boxes, old-fashioned ledgers and type styles from handwritten journals. Eco-friendly elements are also incorporated throughout the redesigned system, including paper stock manufactured from remnants of recycled beer labels and fibers.

title: u.s. cigar co.
description: promo
design studio: hornall anderson design works
art directors: jack anderson, larry anderson
designers: larry anderson, mary hermes, mike calkins, michael brugman
photographer: david emmite
illustrators: john fretz, jack unruh, bill halinann

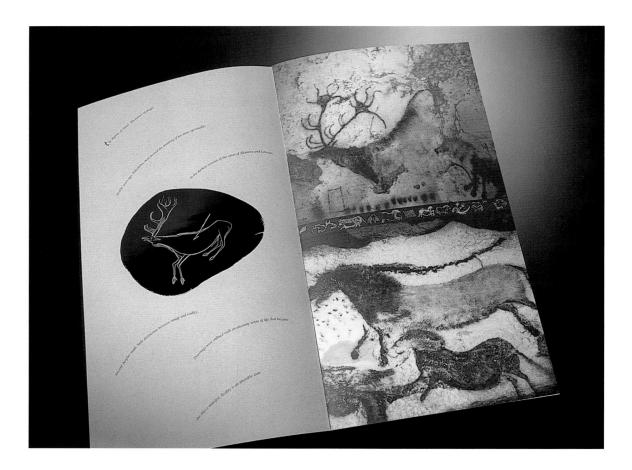

*This piece was designed as a promotion piece for the firm. The "Art of Communication" offers a
unique view into the history of visual communication—how the language of art is similar to signs
and symbols of culture and human thinking; it represents a codex of the human spirit.*

title: "art of communication"
description: promotional literature
design studio: louey/rubino design group inc./santa monica, ca
designer: robert louey

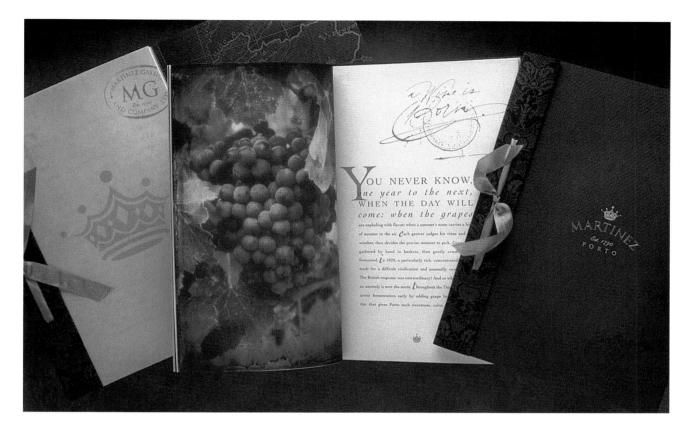

Stimson Lane, a distributor of wine and port, needed a product brochure for Martinez Porto, which is imported from Portugal. Martinez Porto was already being imported into ten states, but the client wanted to import it nationwide and needed a brochure to present to potential distributors, in addition to educating them on the history of port. It was important to the client that the brochure retain the look and feel of a book retrieved from an old trunk found in a dusty attic.

The dark burgundy color of the brochure's cover emulates the deep hue of the port. Completing the overall presentation is a gold ribbon tying the entire piece together, reminiscent of the old-world style of binding. A rich color palette was used throughout the brochure to exude the high quality of Martinez Porto and the history behind the port-making process. An old-world map of the Portuguese region was imprinted on the inside of the wrap-around cover, giving the piece an antiquated look and feel to further accentuate the history of Martinez Porto.

Romantic images of distressed photography fill the brochure to complement the informative text on the facing pages. Descriptive, gold-inked script couples with the straight text (printed in the font Cochin). This text treatment, partnered with parchment-like paper overleafs, reflects the brochure's old-world feel.

title: stimson lane martinez porto brochure
design studio: hornall anderson design works/seattle, wa
art directors: jack anderson, lisa cerveny
designers: jack anderson, lisa cerveny, heidi favour, mary chin hutchinson
illustrator: john fretz (map)
calligrapher: nancy steutz
photographer: tom collicott (aging/distressing of stock photos)
client: stimson lane martinez

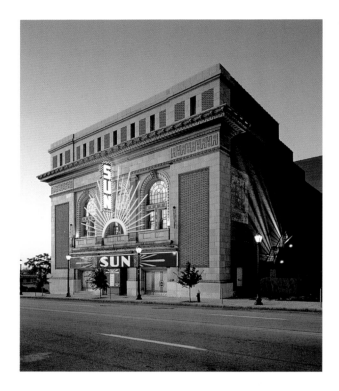

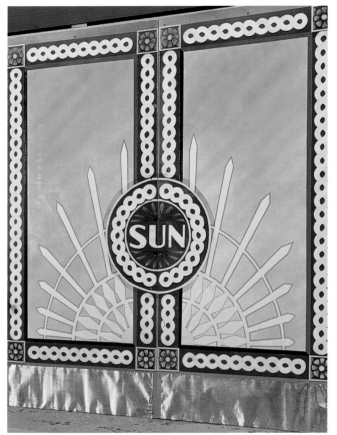

The Grand Center Arts & Entertainment District commissioned a long-term plan and overview for Grand Center as a way to rebuild the urban cultural center for the city of St. Louis. Through federal grants, the district began implementing the master plan with projects to enrich the Grand Avenue theater experience. Serving as the graphic consultant for the master plan, Kiku Obata & Company restored the facade and sign of the Sun Theater.

Designers used the old porcelain enamel sign as a pattern for the new one in aluminum with painted letters and chasing lights. The neon sunburst was copied with 500 feet of colored glass.

The marquee, box office and ornate doors were painted in an elaborated trompe l'oeil sunburst design.

title: sun theater/st. louis, mo
description: exterior graphics and signage
design studio: kiku obata & company/st. louis, mo
photographer: greg hursley
client: sun theater/st. louis, mo

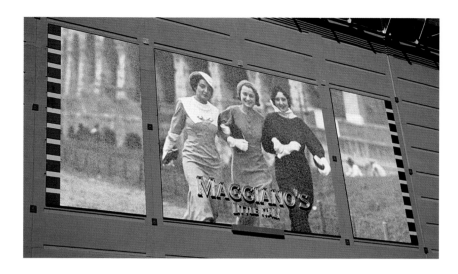

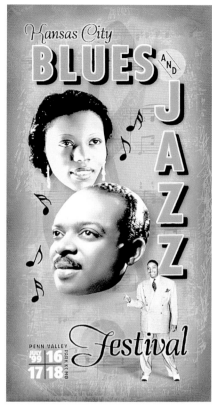

title: maggiano's corner bakery
description: exterior signage for restaurant and bakery
design studio: ema design inc./denver, co
art director: thomas c. ema
designers: thomas c. ema, prisca kolkowski
client: maggiano's

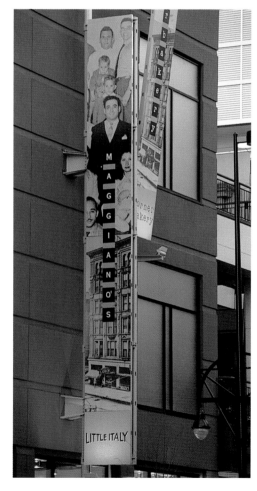

This festival poster was designed to evoke the feeling of the 1930s–1940s blues and jazz era.

title: kansas city blues & jazz festival poster
design studio: muller + co./kansas city, mo
creative director: john muller
art director/designer: jane huskey

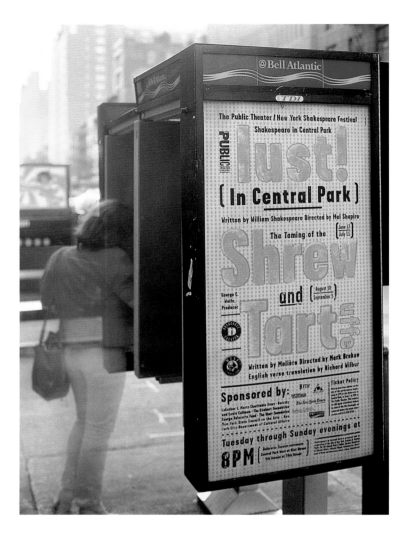

Each summer the Public Theater presents the New York Shakespeare Festival, stagings of Shakespeare in Central Park that are free and open to the public. Since 1994, Paula Scher has designed colorful typographic posters in the tradition of old-fashioned English theater announcements for the Festival.

The Taming of the Shrew *and* Tartuffe *were the festival's 1999 productions. With a wink to news headlines in the Age of Monica, the poster singles out the salacious words "lust," "shrew" and "tart." "Lust! in Central Park" also needles Mayor Rudy Guiliani's vision of a smut-free New York.*

title: "lust! in central park"
description: poster
design studio: pentagram design/new york, ny
partner/designer: paula scher
designer: tina chang

visual relationships

"human life itself may be almost pure chaos, but the work of the artist—and the only thing he's good for—is to take these handfuls of confusion and disparate things, things that seem to be irreconcilable, and put them together in a frame to give them some kind of shape and meaning. that's what he's for—to give his view of life."
katherine ann porter

It's the interaction and tension between images, not simply the images alone, in a composition that creates the life force of a great work. Choosing images based on their potential to create intriguing and provocative juxtapositions raises the intellectual and emotional sophistication in a design.

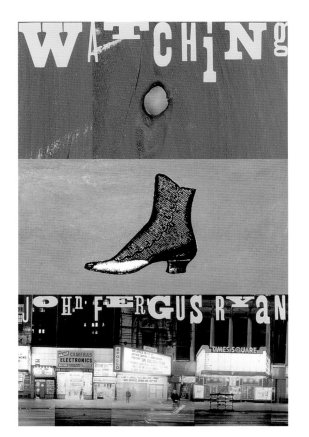

"Watching: *A bizarre, surreal, disturbing novel of the old, very un-Disney Times Square, bordering on pornography,"* explains Steven Brower. *"Seemed to require a seedy approach."*

title: *watching*
description: book cover
design studio: steven brower design/new york, ny
art director: steven brower
designer: steven brower
photographer: langdon clay
client: fox rock books

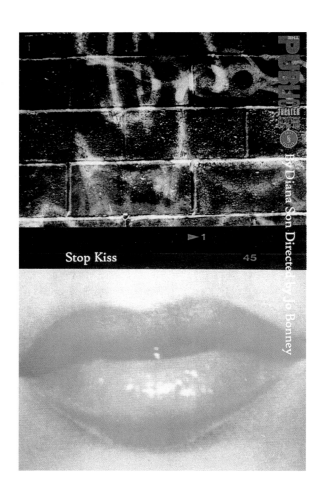

Stop Kiss *poster, 1998: A couple's first kiss meets with violence in the streets of New York.*

title: the public theater, *stop kiss*
description: poster
design studio: pentagram design/new york, ny
partner/designer: paula scher

title: *2wice magazine—night*
design studio: 2wice magazine/
new york, ny
designer: j. abbott miller

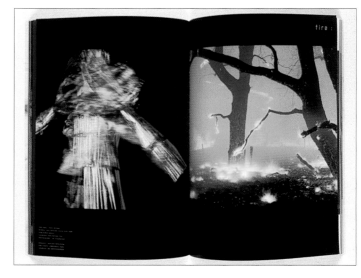

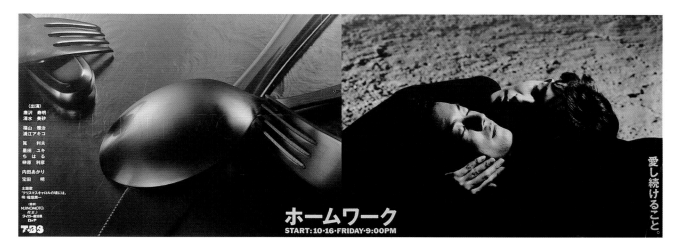

title: "homework"

description: poster for tv drama

design studio: kenzo izutani office corporation/tokyo, japan

art director: kenzo izutani

designers: kenzo izutani, aki hirai

writer: mitsuhiro koike

photographers: masayuki tsutsumi (still photo); tomio watanabe (portrait)

client: tokyo broadcasting system, inc. (tbs)

In contrast to the Navigator, the Continental story is set at luxurious seaside resorts in Martha's Vineyard, the Hamptons and Nantucket. Copy is used carefully and sparingly; the photography carries the weight of the lifestyle communication.

title: lincoln 2000 continental spread

design studio: landor associates, branding consultants and designers worldwide/san francisco, ca

creative director: mark wronski

art director: dennis merritt

designer: lisa quirin

photographers: bob stephens—location; rodney rascona—studio and location; terry vine—stock; ka yueng—stock

copywriter: perrin lam

art buyer: maggie dunn

account: tara stephens

traffic: shane kimsey

product specialist: axel schonfeld

client: lincoln

style

"in all forms of design, the problem of style is central to the creative process; it cannot be ignored. the belief that decoration is useless or frivolous is invalid, for decorative elements enhance communication with graphic resonance. ornament is a potent vehicle for heightening the sensory experience and adding connotative expression to denotative forms."

philip b. meggs

A modern art historian advised: In terms of modern and contemporary art, "life is long and art is short." In the past, for example, the Renaissance period, life was short and art was long; one style or movement lasted a very long time. During a contemporary person's lifetime, one sees many art movements come and go.

Is design shorter? Do trends come and go too quickly? Can one maintain a style of one's own while the style of the time is changing every few (probably three to five) years?

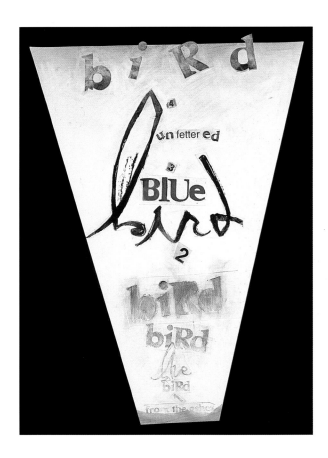

"This work is part of an identity system created for Blue Bird, a design firm founded in a spirit of exploration," says Susan Agre-Kippenhan. "Because most of the work produced by the studio dealt with clients who were trying to communicate abstract concepts, I envisioned a typographic representation of a bird testing its wings and taking flight. As a result the typography is a combination of hand-generated and highly manipulated fonts that not only reflect the individuality of the studio, but also the idea of motion as it changes in space. By creating a unique hand-generated piece of base art, I could digitally integrate the type elements to finalize the composition. The outcome is a piece designed to be read from the ground up, as it literally accommodates a growing sky for the firm to fill."

title: "blue bird"
design studio: compound motion/portland, or
art director: susan agre-kippenhan
designer: susan agre-kippenhan

Can one stay edgy? Does having a style allow one to be edgy? Does conceptual creative thinking allow one to be ahead of the curve?

When you develop a stylistic language, and people enjoy seeing your visual language, or style…then why not maintain it?

"A style is like a language, with an internal order and expressiveness, admitting a varied intensity or delicacy of statement," stated art historian Meyer Shapiro in his quintessential article entitled "Style." Enough said.

As both designer and illustrator, Luba Lukova invents herself as a powerful visual communicator with inimitable style and high graphic impact (see pages 68–69).

"How Do I Look?" is a poster created for an upcoming exhibition of women artists. The title of the exhibition makes reference to the question woman often ask others about themselves—"How do I look?"—and also calls attention to the conspicuous act of self-viewing. Reflecting the duality of the name and the theme of the exhibition, designer Susan Agre-Kippenhan wanted the poster to be both beautiful and vulnerable. The title, which consists of digitally manipulated typography, is elegant and self-consciously ornate. This is accentuated by the flapping armed dress, representing multiple sizes, reflecting a woman's changing image of herself.

These elements are a mix of hand drawing and photography; tying them together is an image of a homey drawstring bag, which creates an awkward asymmetric composition that emphasizes the vulnerability. As the viewer gets closer, the small text reveals a narrative about a woman who stopped wearing a favorite dress because the men she loved did not like it. The poster is hand silk-screened to provide yet another level of uniqueness and a very human quality.

title: "how do i look?"
description: poster
design studio: compound motion/portland, or
designer: susan agre-kippenhan

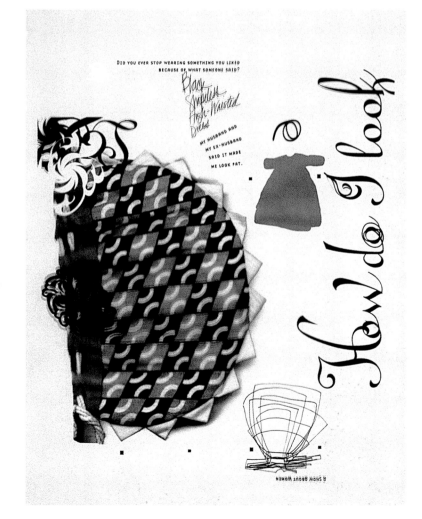

"There is always someone at a birthday party who is not really enjoying the party," notes Jason Logan.

title: "birthday"
design studio: jason logan/
toronto, ontario, canada
illustrator: jason logan

"I buy big sheets of illustration board and cut them into small rectangles," says Jason Logan. *"I also buy primary colors plus black and white tubes of high quality gouache. I add water and just kind of play around with the combinations of color and water. Sometimes it is nice to have nothing in mind and no art directors to think about."*

title: untitled
design studio: jason logan/toronto, ontario, canada
illustrator: jason logan

"I have always liked ducks," says Jason Logan. *"One of my earliest memories is of dragging a decoy duck around with me. I also like to use the technique of scratching, which somehow evokes the process of remembering."*

title: "boy, father, duck"
design studio: jason logan/
toronto, ontario, canada
illustrator: jason logan

title: "fishing"
designer: ed fella

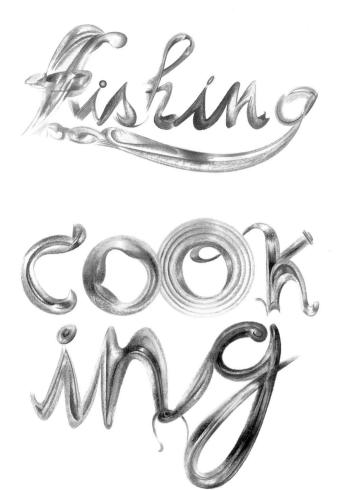

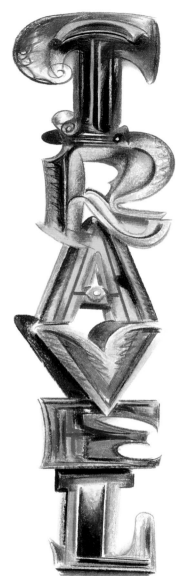

"This lettering is done in what I call 'commercial art style,'" says Ed Fella. "It's meant to be a culmination of past styles from the Victorian and turn-of-the-century through the 1920s, 30s and 40s, to just after mid-century when 'modernism' tried replacing this multitude of unfettered forms. In bringing them back through an idiosyncratic reworking and juxtapositioning of styles, 'post-modern pluralism' allows for a reentry of these now-revalued period forms into a larger mix of design culture. At least that is my intention—along with the love of the artful craftiness that the 'commercial art style' work always attempted during its time."

title: "travel"
designer: ed fella

title: "cooking"
designer: ed fella

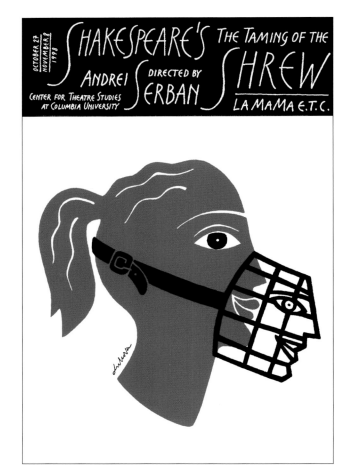

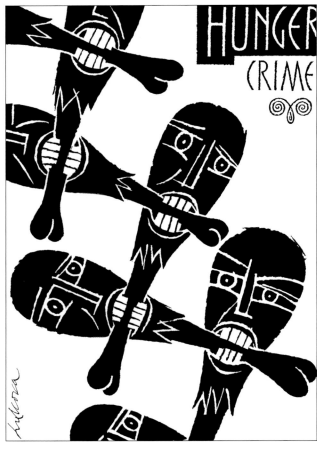

"A poster for an energetic interpretation of Shakespeare's comedy directed by Andrel Serban. I wanted to create a visual joke that the audience will remember after the show is over," says Luba Lukova.

title: *the taming of the shrew*
description: theater poster, silkscreen, 27" x 39"
design studio: luba lukova studio/astoria, ny
designer: luba lukova
illustrator: luba lukova

"These posters belong to the 'Crime' series, a collection of four posters originally designed for Nozone," says Luba Lukova. "The budget for this project was very limited, but to me it was a challenge to create eloquent impacting images using only one color. The series won awards from many design competitions including the Triennale of Political Poster, Mons, Belgium; World's Most Memorable Poster Show, Paris; and the International Poster Exhibition, Fort Collins, Colorado."

title: "hunger crime"
description: social poster
design studio: luba lukova studio/astoria, ny
designer: luba lukova
illustrator: luba lukova

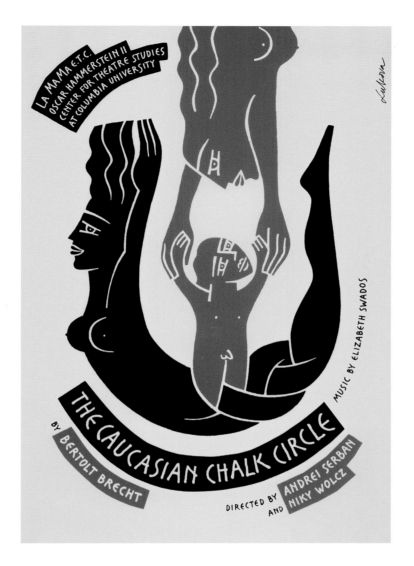

"A theater poster for Bertolt Brecht's play. In his staging director Andrei Serban wanted to emphasize Brecht's humanity instead of his political ideas," explains Luba Lukova. "My goal was to visualize this concept and to create an emotional memorable image."

title: *the caucasian chalk circle*
description: theater poster, silkscreen, 27" x 39"
design studio: luba lukova studio/astoria, ny
designer: luba lukova
illustrator: luba lukova

found materials and objects

"the soul of creativity is looking at one thing and seeing another, making surprising connections between things, generating unusual possibilities."
john chaffee, ph.d.

With a definite nod to Marcel Duchamp, we profess the virtue of found objects and materials. When Duchamp entered his "ready-made," a urinal signed "R. Mutt" and entitled "Fountain," which was rejected by the 1917 Independents exhibition in Paris, art changed forever. Duchamp challenged "the importance of originality in an era of mechanical reproduction…" wrote Grace Glueck, a *New York Times* journalist. Artists were no longer identified by their ability to craft a work and by originality, since no crafting or originality was involved in a "ready-made." Artists became witty intellectuals who could make something art merely by choosing it as such or by replication.

This jolt is an homage to Duchamp, Dadaism and every designer, illustrator, art director and artist who goes through the garbage, haunts junkyards, scrap yards and auto graveyards or just looks at a "ready-made" and says, "A-ha!"

The clever and appropriate use of a "No Parking" sign—object-for-drivers—in Donna Reynolds' three-dimensional illustration affords the viewer a little chuckle (see page 73).

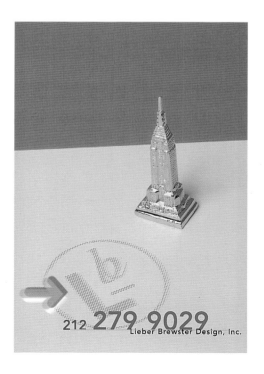

"To help our clients remember our new location, across the street from the Empire State Building, we chose to feature the landmark juxtapositioned to the Lieber Brewster Design logo in our moving announcement," says Anna Lieber. *"For our photograph, we cast our logo opposite an authentic model of King Kong's old perch, which we purchased at the Empire State Building's Gift Shop."*

title: moving card
design studio: lieber brewster design/new york, ny
art director: anna lieber
designer: anton ginzberg
client: lieber brewster design

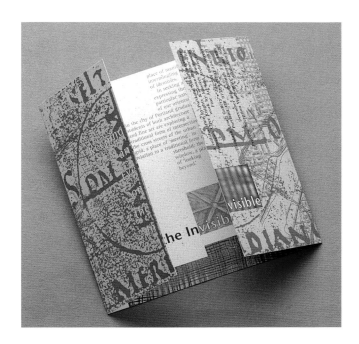

This announcement was created for an exhibition of work by artists and architects. The title refers to the "invisible" 200-square-foot grid that defines the city of Portland, Oregon, and was utilized in the work of the participants. This small, two-color announcement was created collaboratively with the curators of the exhibition, an architect and artist, whose approach to design was influenced by their respective disciplines. An additional goal of the piece was for the viewer to experience the process that was used in the creation of the work showcased in the exhibit. As a result, a square motif was chosen as the primary design element, a reference to the grid. This square is reflected throughout the work from its overall shape to numerous interpretations: grid-like copy blocks, stepped details, woven materials, city maps and square images of ancient surveying tools. By breaking up and moving the word "invisible" against a variety of backgrounds, the announcement also asks the viewer to consider the question of what is visible and what is not, just as the grid that defines the city is invisible but imprinted on every intersection.

title: "keeping an eye on the invisible"
description: exhibition announcement
design studio: compound motion/portland, or
designer: susan agre-kippenhan

"Portland State University asked me to design this postcard promoting their study abroad program," says Susan Agre-Kippenhan. "This program immerses the student in the culture and art of Rome and its surrounding area. My design is intended to read like a personal scrapbook collection that reflects the experience of studying in such a vibrant environment. The viewer takes in recognizable images from masterworks that would be seen at the museums and monuments that would pass by as one traveled through the city. Also included are images that speak to the day-to-day details of living and working in Rome: subway tickets, sketchbook drawings and images of fellow participants. A closer look reveals another layer, tiny type labels and glimpses of text from old books. The collage was scanned in after being created by hand with color photocopies and actual objects. The fine red type was laid over the image digitally and serves as a unifying device that reminds the viewer that all the experiences depicted are available through the program. The back of the card includes the ubiquitous humorous bowl of spaghetti, scanned from a T-shirt purchased in Rome."

title: "study in rome" collage
description: postcard
design studio: compound motion/portland, or
design/art: susan agre-kippenhan
designer: susan agre-kippenhan
client: portland state university

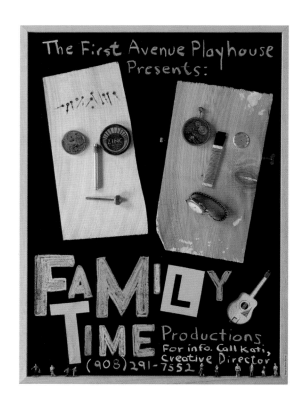

"Since this was to solicit young recruits to the children's theater, I made the poster look like a blackboard with colored chalk that you would place outside or in the window," explains Steven Brower.

"I always liked the look of the blackboards placed outside of restaurants and stores that nondesigners draw on for the day's specials. This seemed an appropriate place to begin a recruitment poster for a children's regional theater. Playing with the traditional drama/comedy icons and the concepts of 'time' and 'stage' added new elements to this approach."

title: family time poster
design studio: steven brower design/new york, ny
art director: steven brower
designer: steven brower
client: first avenue playhouse

The design of the brochure (shown here), postcard and letterhead make use of traditional and archival images found in libraries and flea markets. Printing is limited to one and two colors throughout. The brochure is unbound, in order to feel more like a handmade project; the typewriter-style typeface (Trixie) reinforces the connection with homemade recipe books often scribbled in old exercise booklets.

title: "moveable feast" brochure
design studio: teikna graphic design, inc./
toronto, ontario, canada
creative director: claudia neri
copywriter: michael liss
illustrator: archival, garry campbell
client: butterfield & robinson

"It took months, but it was a happy day when this old wooden bootjack and a bingo game finally collided in my cluttered studio," says Donna Reynolds. "I am inspired by Early American folk dolls...their simplicity is stunning. I wanted this gal to have the same kind of simple look despite her naughty nature."

title: "bingo babe"
description: found object illustration
illustrator: donna reynolds
studio: racer-reynolds illustration/oakland, ca

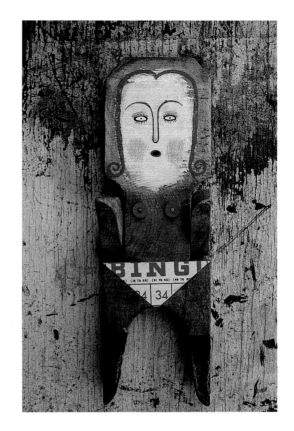

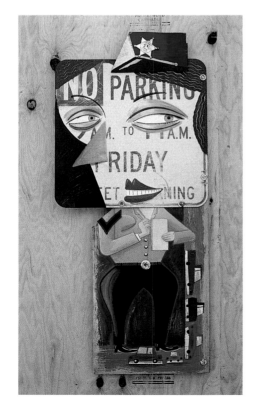

"The parking sign begged to be given a face," explains Donna Reynolds. "Who is the meter maid that leaves her nasty mark on my car...friend or foe? I wanted her to be much bigger than the cars...like a Godzilla...and searched for toy cars at first. Then I got tired of looking for 'cool' cars and cut these car shapes out of my stained baking sheet. I'm glad I did...I like these better."

title: "meter maid"
description: found object painting with parking sign
illustrator: donna reynolds
studio: racer-reynolds illustration/
oakland, ca

conceptual typography

"the visual nature of typography is extraordinary, for it can combine the time–space sequence and rhythm of music, the linear structure of language, and the dynamic space of painting."
philip b. meggs

Relishing in the shape of every serif and stroke of a letterform, and viewing type as having a voice beyond the literal meaning of words, allows you to push typography to its fullest level of connotation.

In many cases, type is the only visual a designer or illustrator uses. Not only can give you type a voice, you can give it a beat, as in John Steven's vibrant hand-lettering. Feel the dance rhythms! (See page 76.)

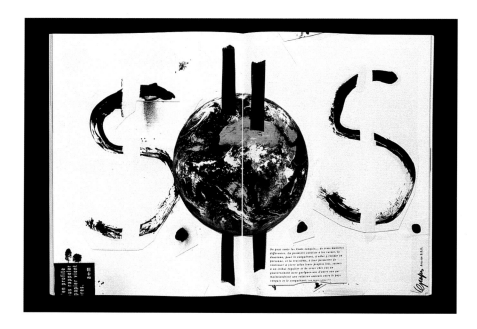

"To symbolize suffering, the crossbars from the dollar sign pierce the globe. This poster speaks to the issue of globalization and the belief that the world is being run by money," says Pierre Bernard.

title: "s.o.s. against marketing of the world"
description: poster
design studio: atelier de creation graphique/
paris, france
illustrator: pierre bernard

"The event is a summer celebration of the visual and performing arts," says Lanny Sommese. "I decided to manipulate the letterforms in the title to reflect the nature of the overall event. Since I have done the poster for this event for twenty-five years, I'm always trying a new image or stylistic approach. Consistently the challenge is not to parody myself."

title: central pennsylvania festival of the arts poster
design studio: sommese design/state college, pa
art director/designer/illustrator: lanny sommese
client: central pennsylvania festival of the arts

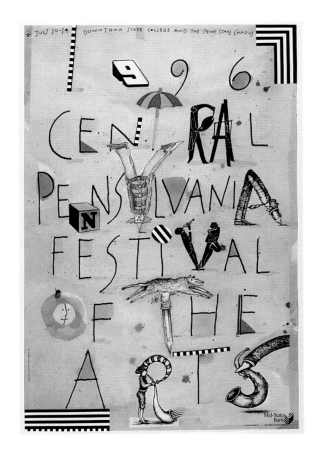

"Mortal Peril: *For an expose of the medical system in this country, I used an actual X-ray as art,*" says Steven Brower.

title: *mortal peril*
description: book jacket for nonfiction work
design studio: steven brower design/new york, ny
designer: steven brower
art director: steven brower
client: addison & wesley publishing

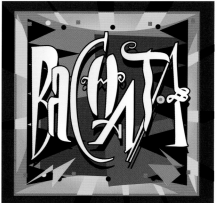

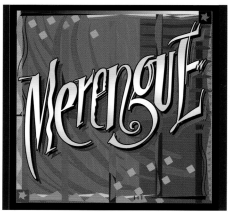

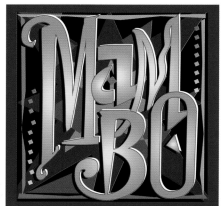

These dance names were created for a dance club as lighted (backlit) graphics.

title: dance names (bachata, salsa, merengue, mambo)
description: hand-lettering
design studio: john stevens design/ winston-salem, nc
designer: john stevens

"Issac's First Swim" is a double-page spread from the third brochure in the Bravo PhotoMasters Series presented by—and printed on—Bravo, the number one paper from Eddy Specialty Papers. Beautiful photojournalistic photographs of Larry Towell, rich in human contexts, are artfully merged in a thoughtful design and typography creating one expressive and long-lasting form.

title: "isaac's first swim" from "bravotowell" brochure— bravo photomasters series
design studio: emerson, wajdowicz studios/new york, ny
designers: lisa larochelle, manny mendez, jurek wajdowicz
photographer: larry towell
writer: larry towell
client/publisher: domtar, eddy specialty papers

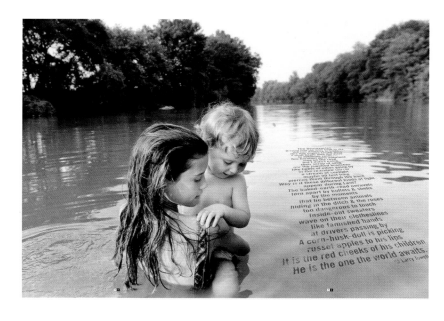

"*Commissioned by the* National Post, *this illustration is for a book review,*" *says Jason Logan.* "*The book is about a troll, a forest and semiotics, among other things. I really enjoyed getting the phrase 'burger bundles' in there.*"

title: "troll"
description: illustration
design studio: jason logan/toronto, ontario, canada
illustrator: jason logan
client: *national post*

This poster was inspired by Piccolo's style of abstraction. The flavor also incorporates some of the golden-era-type stylings of Hollywood. All together, this smorgasbord of a poster somehow still manages to be harmonious in a world all its own.

title: "the fine line"
description: poster
design studio: dbd international, ltd./menomonie, wi
art direction/lettering/illustration: david brier

In this poster for Seattle Symphony's Popular Culture Series, dramatic cropping, bold colors and a fractured headline alert viewers that this music series is unlike most classical fare.

title: seattle symphony popular culture poster
design studio: art-o-mat design/seattle, wa
designer: mark kaufman, jacki mccarthy
photography: various
client: seattle symphony

wit

"the truth isn't the truth until people believe you, and they can't believe you if they don't know what you're saying, and they can't know what you're saying if they don't listen to you, and they won't listen to you if you're not interesting, and you won't be interesting unless you say things imaginatively, originally, freshly."

bill bernbach

"at push pin we found corruption was more interesting than purity."

milton glaser

"they are madly in love—he with himself, she with herself."

yiddish proverb

"if you're looking for my footprints, they are upstairs in my pajamas."

groucho marx

CLINTONISM

Twin brothers cleverly borrow Doublemint gum's design to create stationery for their graphic design firm, Double Entendre (see page 81).

"The source is obvious," says Lanny Sommese. "However, I did spend quite a bit of time deciding which way the 'Wang' should wave (to the left or right?). In my image I decided to have it veer to the audience's left, but to Clinton's right. Oh well, it doesn't seem to matter to Clinton which way it goes. (Sexually or politically!)"

title: "clintonism"
design studio: sommese design/
state college, pa
art director: lanny sommese
designer: lanny sommese
illustrator: lanny sommese

A lettering design for a Newsweek cover. It was bumped by "some other story."

title: "president clinton?"
design studio: john stevens design/winston-salem, nc
designer: john stevens
client: newsweek

"A fairly hungry (and good) photographer in town set up some shots of actual Humane Society Animals," explains Scott Hardy. "We were just looking at that shot of the cat one morning. The expression on its face seemed to be saying: 'What the hell are you doing? And why are you doing it to me??' A line would have gotten in the way. And why say it? The coupon with the cut line 'Snip Here' just appeared in front of us (right where we placed it) as the reason for the cat's dismay. Two months after we placed this campaign, a very similar idea showing the hind end of a cat appeared in the 'One Show'...Damn! I still think it works better, seeing the cat's (or dog's) expression with the coupon strategically placed."

title: "snip here"
description: humane society spay & neuter ads
agency: publicis/salt lake city, ut
art director: scott hardy
writer: bryan deyoung
client: humane society

Created for a design firm owned by twin brothers.

title: double entendre stationery and logo
design studio: double entendre inc./ seattle, wa
designers: richard a. smith, daniel p. smith

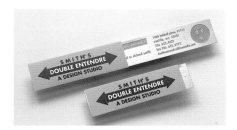

Hi. I'm **JUDI BOLDT**. Actually, I'm Judi's *business card*. I'm also her appointment card. I tirelessly proclaim her phone number (**252-6110**). I occasionally win her free lunches in those fishbowl drawings, and sometimes I'll help her remove food stuck between her teeth. And do I get any thanks? Zero. I sit in a cramped box for weeks at a time until the precious **HAIR STYLIST** yanks me out, writes an **APPOINTMENT TIME** here＿＿＿＿＿＿＿＿＿, and hands me to some stranger where I'm shoved into a wallet or painfully tacked to some bulletin board or stuck to a cold refrigerator door with magnets. It's *cruel*, I tell ya. And then, when the appointment is over and the customer goes skipping home from **GATEWAY** with his or her spanking new coif, I'm discarded like ⬇

so much common rubbish. Oh it's a wretched, thankless, woebegone existence I lead. Still, I'm not defeated. No, I'm strong. And I will survive. But I need your help. Call Judi. Plead with her not to hand me out (though I don't mind working the fishbowls). If she absolutely must, ask her to tell her customers to consider my feelings. Though I'm made of cellulose pulp, derived mainly from wood, rags, and certain grasses, I have feelings you know. I *need* sunlight. I *need* music. I *need* human contact. And when the hair appointment is over, I should never be tossed in with the banana peels and HoHo® wrappers. I belong on a pedestal or perhaps in a shrine created for me and my business card compatriots. Is this asking too much? Am I crazy?? I think not.

"For a hair designer, personality can be as important as talent in getting clients and keeping them," says Steve Sandstrom. "A hair designer builds relationships and trust on a very personal level. Hair designers touch people and help them mold their own personal images. The business card created for Judi Boldt is a way of reflecting her unique personality and quality while still delivering the essential information (in boldface).

"The cards were printed in the margin beyond the trim of another job. This kept costs at a bare minimum and produced an excessive quantity so Judi can disperse them freely and in abundance. She never saw the concept until it was printed and delivered. Trust was part of the deal."

title: judy boldt business card
design studio: sandstrom design/portland, or
designer: steve sandstrom
copywriter: david brooks

whimsy

"my wife maira is an artist and an important collaborator. she always makes me approach a problem backward and upside down. i also listen to children, who provide a constant inspirational whirlwind of difficult questions and free association."
tibor kalman

"I did it on a whim," said the designer with a playful look in her eye.

Creating a fanciful quality, giving a design a light, illogical or comical spin isn't easy. There's a fine line between whimsy (which we love because it's charming) and silly (which we don't even like because it's not clever). Clearly, the designers in this book who had the impulse to wield a whimsical jolt have the power of imaginative vision.

The whimsical characters spouting typographic flavors add to the playful charm of the packages by Hornall Anderson Design Works (see page 83).

The slide lecture, by a prominent graphic designer, seemed to lend itself to an "eye—eye" and "eye—mouth" treatment since he was speaking of his work and how he saw the world.

title: james victore lecture
design studio: sommese design/state college, pa
art director: lanny sommese
designer: lanny sommese
illustrator: lanny sommese
client: penn state school of visual arts

When Cloud Nine enlisted the help of Hornall, they already had much of their products in specialty stores. With the introduction of their organic mints, they planned to break into the larger grocery store chains as well. The client approached Hornall equipped with the name "Speakeasy." Hornall developed the project from there, exploring several different concepts and eventually agreeing on the idea of "talking head" characters/mascots. These mascots reflected the varying flavors and were illustrated with nonsensical words flowing from their mouths. Originally the mascots were human-like, but soon developed into "flavor" mascots, which reflect a more fun and playful feel. The flavor mascots also enable the packaging to communicate the mint flavors quickly and in a fun manner. In addition to the individual mint packages, Hornall also designed the shape of the mints and the display trays.

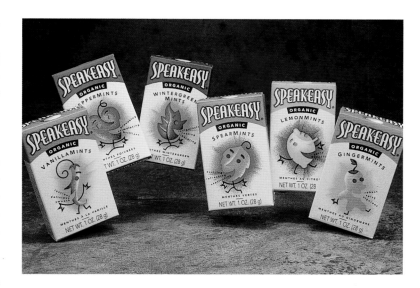

title: cloud nine "speakeasy" mints packaging
design studio: hornall anderson design works/seattle, wa
art director: jack anderson
designers: jack anderson, jana nishi, heidi favour, david bates, mary hermes
illustrators: julia lapine, dave julian, jana nishi
client: cloud nine

The point of view of this book is that advertising is good for us. The title suggested the solution.

title: *lead us into temptation*
description: book cover
design studio: steven brower design/new york, ny
collage and design: steven brower (painting by rubens)
publisher: columbia university press

"We had a bunch of ideas that showed the hornbill with 'attitude' headlines," says Brian DeYoung. "We did 'nose' jokes, we did evolution jokes, we did Barbra Streisand jokes...I don't know. Finally one morning it just seemed a whole lot more hilarious, showing other birds that wanted to get into the act."

title: tracy aviary/hornbill exhibit campaign
description: ad campaign
agency: publicis/salt lake city, ut
art director: matt jones
copywriter: bryan deyoung
client: tracy aviary

The GrateFish Drain uses the universally understandable symbol of a fish to remind people not to pour motor oil or other harmful chemicals down storm drains. Cost, manufacturing process, strength and waterflow parity with existing products were objectives of the design.

title: gratefish drain
design studio: mauk design/san francisco, ca
designers: mitchell mauk, laurence raines

Jamba Juice Company is a leading retail purveyor of blended-to-order smoothies, fresh-squeezed juices and health snacks. The company's goal is to enrich the daily experience of its customers through the life-nourishing qualities of fruits and vegetables.

The marketing objective for Jamba Juice was to develop a logotype and kit of parts that would distinguish them from their competitors in the category of fast-food alternatives. In doing so, the look of the company needed to become festive and fun without appearing trendy, with the stores and products appealing to young and old alike. The ultimate end was to develop an overall brand identity and trade dress that would communicate the fact that Jamba Juice is the authority on juice and nutrition, or as they describe it, "a meal in a cup."

To communicate the client's desired objective, Hornall used a palette of bright colors that appear throughout the stores and their collateral materials. The typefaces chosen, Bembo and Meta, are "friendly-looking fonts that are easy to read. The illustrator was chosen because of the sense of fun in his work. His illustrations are playful, yet sophisticated."

title: jamba juice identity program
design studio: hornall anderson design works/seattle, wa
art director: jack anderson
designers: jack anderson, lisa cerveny, suzanne haddon
illustrator: mits katayama
client: jamba juice

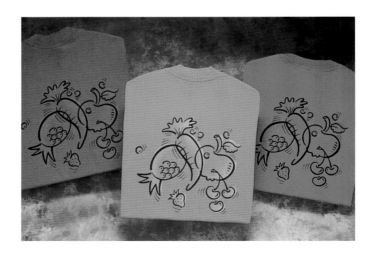

challenging the container

"the visual objects in a composition are like so many cosmic bodies attracting and repelling one another in space."
rudolf arnheim

Every mark you make relates in some way to the edges of a printed or an electronic page. Horizontal and vertical movements within a rectangular container, such as a business card, a poster, or computer screen, repeat the edges of the container and so complement and stabilize. Diagonals and curves oppose the edges of a rectangular container and create tension. Although the use of mark and movement relative to the container is a fundamental of composition, not every one employs this knowledge to full advantage.

We maintain that composing diagonals or curves within a rectangular container, manipulating the interior relationship of scale of elements to the size of the container, or utilizing dynamic positive and negative interrelationships can challenge the container yielding a variety of compelling effects.

For example, one can make the physical size of a page seem bigger than it is through the manipulation of scale and counterpointing movements. The designer who can manage this jolt is the master of his or her design domain!

In the "roads" spread for Landor Associates' Lincoln 2000 Continental print literature (see page 87), the counterpointing curves in the roads create a powerful composition that challenges the container. In another inspired spread that begins with "A day at the beach," positive and negative shape interrelationships make the physical size of the page seem bigger than it is, by pressing against the boundaries. Again, the confrontation with edges challenges the page.

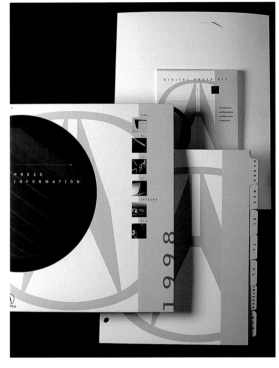

"This series of press kits for the 1998 line of Acura automobiles emphasized precision and excellence," says Petrula Vrontikis. "The design had to be conceptual and not emphasize any one model. The client placed difficult parameters around the design. It couldn't look like 'this or that,' basically anything that existed, leaving me very little to work with. The result was a fresh new look for them that was very well received by the press. The kit contained two binders, envelopes for disks, tabs and insert sheets."

title: acura press kit
design studio: vrontikis design office/los angeles, ca
art director/designer: petrula vrontikis
client: acura

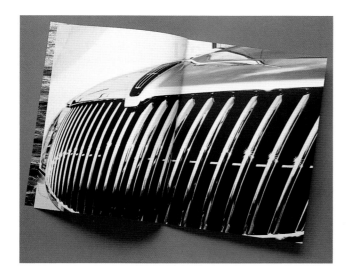

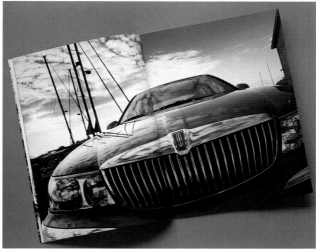

In contrast to the Navigator, the Continental story is set at luxurious sea-side resorts in Martha's Vineyard, the Hamptons and Nantucket. Copy is used carefully and sparingly, the photography carrying the weight of the lifestyle communication.

title: lincoln continental 2000
design studio: landor associates, branding consultants and designers worldwide/ san francisco, ca
creative director: mark wronski
art director: dennis merritt
designer: lisa quirin
photographers: bob stephens—location; rodney rascona— studio and location; terry vine—stock; ka yueng—stock
copywriter: perrin lam
art buyer: maggie dunn
account: tara stephens
traffic: shane kimsey
product specialist: axel schonfeld
client: lincoln continental

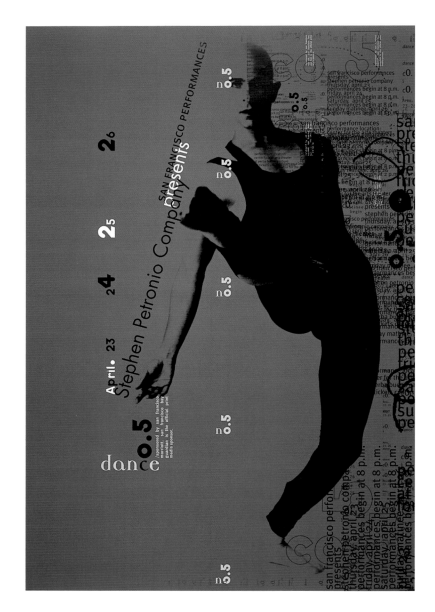

A series of posters and bus shelters designed for San Francisco Performances that announces upcoming performances by Anne Teresa de Keersmaeker/Rosas, Wim Vandekeybus/Ulltima Vez, DV8 Physical Theatre, Eiko and Koma with the Kronos Quartet and the Stephen Petronio Company. The series and performances feature quite different elements of dance, and the individual posters needed to reflect the works of these various dance companies. The companies had little or no photography to work with, so the typography became responsible for evoking the dance or experience of each performance.

title: san francisco performances posters
design studio: jennifer sterling design
art director/designer/illustrator: jennifer sterling
copywriter: corey weinstein
client: san francisco performances

cross-formatting

"what is more practical than creativity that stops you and makes you look, listen and believe?"

bill bernbach

Thinking "out of the box" allows you to take a format that belongs to one book category and use it for another, creating a visual surprise. A wilderness guide seems like a natural format for Network General's Annual Report theme of "We are prepared to guide you!" designed by Cahan & Associates (page 92). You can relate to it because it's familiar, yet this annual report surprises because it's been cross-formatted.

"This piece was designed for photographer Erik Butler as his moving announcement/promotional piece," says MaryAnne Mastandrea. "We created a mini portfolio of six square cards contained in a jewel case, which can also be used for display. The cards were designed to showcase Erik's color and black-and-white photography. The top portion of each card features a saturated color photo showing movement. A black/white photo strip runs along the bottom to suggest moving images like a film reel. The backs of all the cards form one large image when put together."

title: erik butler photography promo piece
design studio: mastandrea design, inc./san francisco, ca
designer: maryanne mastandrea
photographer: erik butler
client: erik butler photography

Although Adaptec was known as the leader in Small Computer System interface (SCSK) solutions, what many financial analysts and most investors did not know is that Adaptec also offers the best technology for moving digital data in any environment. Cahan & Associates created an annual report in the form of a children's book in order to make this universal message accessible to everyone. Wally, Molly and Data, the dog, star in three chapters about how Adaptec helps computer users everywhere move their data quickly, accurately and reliably.

title: adaptec annual report
design studio: cahan & associates/san francisco, ca
art director: bill cahan
designer: kevin roberson
client: adaptec

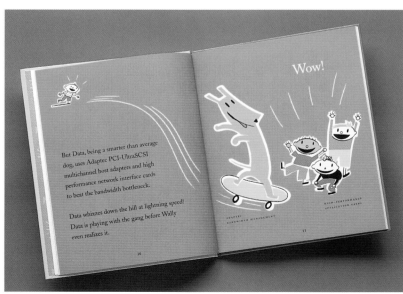

Adaptec designs, manufactures and markets a comprehensive family of hardware and software solutions, collectively called IQware Products. Colorful, bold visuals were chosen to convey strategic messages and core competencies. The comic-book style is a powerful, familiar medium that grabs the reader's attention.

title: adaptec annual report
design studio: cahan & associates/san francisco, ca
art director: bill cahan
designer: craig clark
client: adaptec

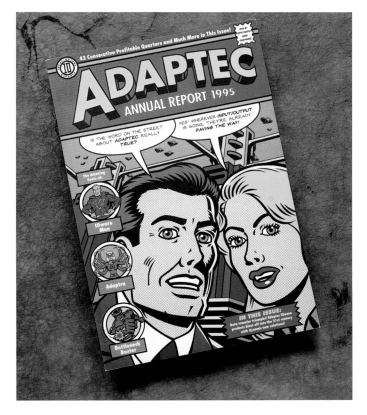

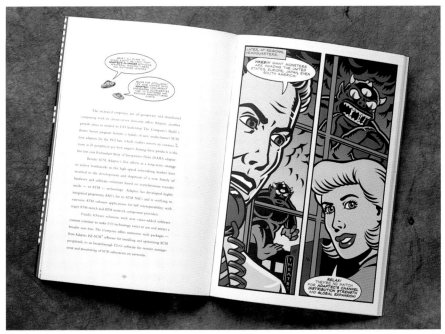

Network General is a leader in network fault and performance management and can help guide customers through the complex terrain of today's computer networks, keeping them on track with systems, tools and services that provide everything for survival. The wilderness guide theme and its colorful illustrations provide a quick and easy understanding of the company and what they are providing. The small format, rounded corners, schoolbook type and nostalgic illustrations make the book friendly and more accessible.

title: network general annual report
design studio: cahan & associates/san francisco, ca
art director: bill cahan
designer: sharrie brooks

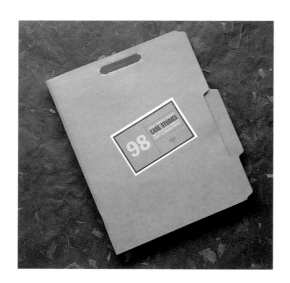

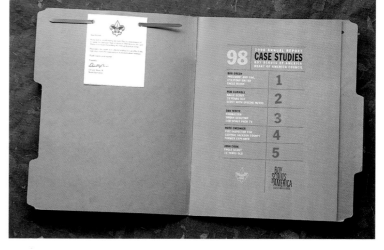

title: boy scouts of america annual report
design studio: muller + co./kansas city, mo
art director/designer: mark voss

push and pull

"pictorial space is a symbolic space, and its visual organization is a symbol of vital feeling."
suzanne k. langer

All designers manipulate the formal design elements to create a design solution. However, some designers are capable of controlling the elements in such a way as to shape, bend and draw out forms, colors, letterforms and shapes with great pliancy, to yield an illusory push and pull of three-dimensional space on the two-dimensional surface. Their works have an enviable plasticity, a manipulation of the elements that cause the illusion of atmosphere, multiple spatial layers and spatial positions.

Hans Hofmann, painter and educator, is known for teaching students to push and pull color and form to create the illusion of space. This jolt is an homage to him and to all the graphic design educators who advocate the same thinking.

In Jennifer Sterling's Pina Zangaro catalog (see page 94), the various elements sit in different positions in space. All the elements feel malleable; the handling of the elements demonstrates great plasticity, yielding a push and pull of the space.

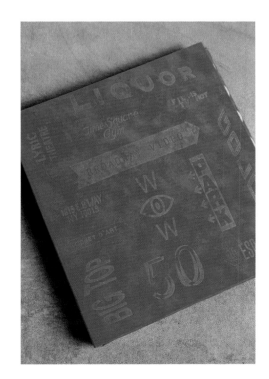

"Broadway Video, the company that produces Saturday Night Live, *also purchased a large collection of vintage television series, animated shorts and feature films," says Frank Viva. "For the most part, this group of properties, including everything from the* Lone Ranger *TV series to Fellini's classic film* 8½, *had no common thread. We therefore looked at Broadway Video's location in the Brill Building on Times Square as a source of inspiration. We felt it would be appropriate to use the signage to give a unique visual language to this catalog directed at TV programmers."*

title: broadway video entertainment product catalog
design studio: viva dolan communications and design inc./
toronto, ontario, canada
art director/designer: frank viva
client: broadway video

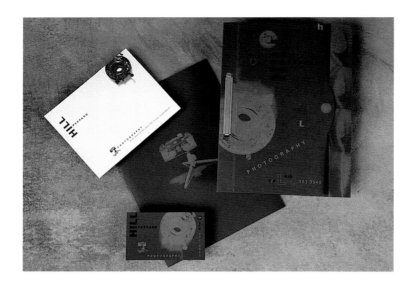

"A mailing container for a Toronto-based photographer whose work is reminiscent of Man Ray's early twentieth-century fashion photography. He needed a way to mail out black-and-white prints to a small selective mailing list. We produced the two-color (silver and dark red) mailer to complement his work."

title: hill peppard promotional mailer
design studio: viva dolan communications and design inc./ toronto, ontario, canada
art director: frank viva
designers: jim ryce, jill peters
photography: hill peppard

Although the summer catalog created a large number of orders for the Pina Zangaro product line, it also produced several product knockoffs in retail stores. The quality of the Pina Zangaro line, created by Tim Mullen, was due largely to the product design and quality control of his company. By designing a book that allowed the viewer to see Tim's initial doodles, sketches and thoughts, Jennifer Sterling repositioned him as a product designer rather than a faceless "company."

title: pina zangaro fall catalog
design studio: jennifer sterling design/san francisco, ca
art director/designer/illustrator: jennifer sterling
copywriter: tim mullen
photographer: dave magnusson

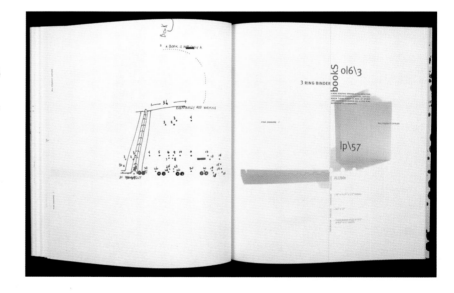

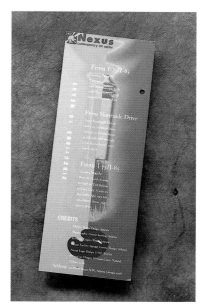

"In this city the key to success is not letting success go to your head," says Wages. "There were times when we were so busy we hardly saw friends and families for weeks. Then, bang, you turn around and wonder how you're going to make rent. I learned you never take people for granted: not your family, friends, colleagues or vendors, and especially not your clients. They are the people you keep."

title: nexus promotional brochure
design studio: wages design/atlanta, ga
designer: joanna tak
photographer: grover sterling
client: nexus

This poster is printed on see-through plastic and hung from the ceiling in the gallery. The poster can be seen from both sides in the student area. Vellum was used to depict the views and insights from the various speakers. A screen print of the poster is featured in the middle to depict the process to students.

title: ccac concept symposium poster
design studio: jennifer sterling design/san francisco, ca
art director/designer: jennifer sterling
photographer: marko lavrishka
client: california college of arts and crafts

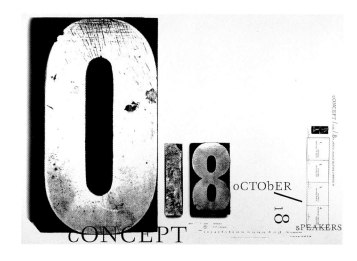

showcases

"design is intelligence made visible."

rick eiber, red

1968

1976

1984

1992

stefan sagmeister

sagmeister inc./new york, ny

design philosophy

"I am mostly concerned with design that has the ability to touch the viewer's heart. We see so much professionally done and well-executed graphic design around us, beautifully illustrated and masterfully photographed; nevertheless, almost all of it leaves me (and I suspect many other viewers) cold.

"There is just so much fluff: well-produced, tongue-in-cheek, pretty fluff. Nothing that moves you, nothing to think about; some is informative, but still all fluff.

"I think the main reason for all this fluff is that most designers don't believe in anything. We are not much into politics, or into religion, have no stand on any important issue. When your conscience is so flexible, how can you do strong design?

"I've seen movies that moved me, read books that changed my outlook on things, and listened to numerous pieces of music that influenced my mood. What qualities do these pieces have in common? What do they need to touch my heart?

"Here is an attempt to list some of the factors:

 1. the ability to make you see things in a new way

 2. reminders of your youth

 3. passion and commitment

 4. unexpectedness

 5. virtuosity of craft or technique."

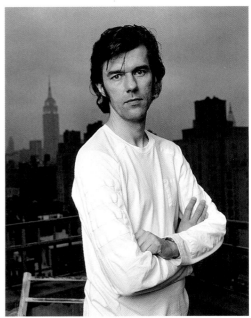

Photograph by Rainer Hosch

"The singer of Skeleton Key brought in a quirky illustration of a Mexican guy he had done on a postage stamp," explains Stefan Sagmeister. "There was no time and no budget, so we just cut the stamp up, enlarged it, put some other illustrations behind it and shipped the whole thing.

"Since it was a one-color job, we could talk the label into matte laminating the board. We wound up with two hits of black anyway to get that cherished 'No more black' comment from the audience."

title: skeleton key ep
design studio: sagmeister inc./new york, ny
art director: stefan sagmeister
designers: stefan sagmeister, veronica oh
illustrators: erik sanko, veronica oh, stefan sagmeister
client: motel records

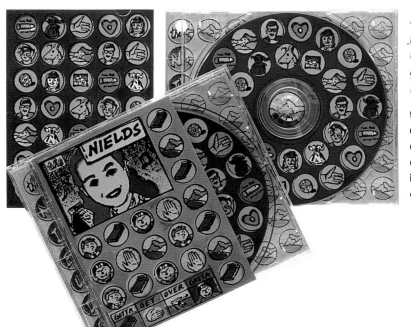

Stefan Sagmeister notes, "The Nields are a rock-influenced folk band. We took different elements from the lyrics and made little symbols out of them. To achieve a layered effect, we cut the booklet short, making the CD itself and the inlay card visible from the outside."

title: the nields, *gotta get over greta*
description: cd package
design studio: sagmeister inc./new york, ny
art director: stefan sagmeister
illustrators: stefan sagmeister, carola pfeifer, stock
client: razor & tie

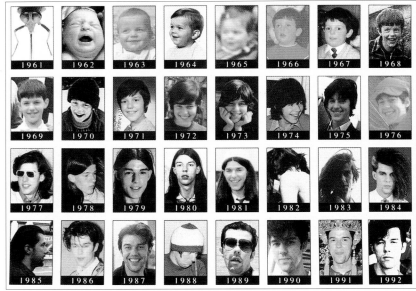

According to Stefan Sagmeister, "This birthday invitation shows myself every year. Obviously, 1984 was my most successful one."

title: 30th birthday invitiation
design studio: sagmeister inc./new york, ny
designer: stefan sagmeister
photographers: mama sagmeister, papa sagmeister, andrea sagmeister, christine sagmeister, etc.

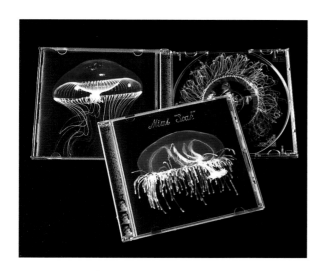

"We designed a packaging featuring numerous jellyfish in all their different appearances for the New York band Mimi's debut album, Soak," says Stefan Sagmeister. *The floating, hovering quality of the imagery reflects the sound and mood of this excellent album."*

title: mimi cd cover, *soak*
design studio: sagmeister inc./new york, ny
concept: stefan sagmeister
designer: hjalti karlsson
photographers: joseph cultice, carl may, stock

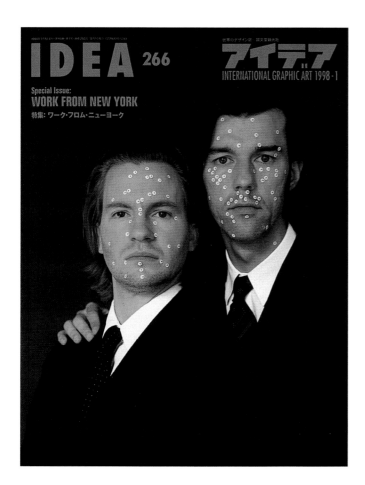

title: *idea* magazine cover
description: magazine cover
design studio: sagmeister inc./ new york, ny
concept and designer: stefan sagmeister
photographer: tom schierlitz
client: *idea* magazine

Stefan Sagmeister: "The cover for the New York issue of the Japanese design magazine Idea. *The driving force behind design in New York seems to be money and love. If you connect the numbered dots on our faces with a line, that driving force is visualized by a bag full of dollars and a beautiful girl. Tom Schierlitz shot a very corporate portrait of designer Hjalti Karlsson and myself to emphasize that the design here is so much more business oriented than in other major design centers like London or Tokyo."*

robert louey

louey/rubino design group, inc./santa monica, ca

company philosophy

"Design is visual communication. Create powerful images that communicate, inspire and inform. Distinct voices that leap across boundaries of culture, place and time and create dialogue."

introduction

"I think that designing is a lifestyle rather than a job. Inspiration comes from observing and engaging in all aspects of life. The thirst for knowledge is a continuing quest…to understand, to love, to question art gives us a vantage point into the human spirit. This knowledge base covers not only the new but the ancient as well. It is sad when some speak of ousting the old for the new. I see all new knowledge as an addition to the legacy and arsenal of intellect rather than a replacement. All the gathered knowledge of the past offers itself to make us wiser and sparks our curiosity. Stay curious, observe every detail, gather inspiration through living and seek elegant solutions."

research, research, research

"The foundation of any project. Only by thoroughly understanding and knowing a client's business can you truly communicate intelligently and solve complex problems. We need to know all the facets of the subject, not just the glamorous parts but the dirty 'in the trenches' parts as well. We live it to be able to express it. The best part of being a communicator is that every project becomes an opportunity to learn something new."

the client

"We find ourselves becoming the client's best advocate and loudest voice. They become our partners. We become eager to tell their story. Their passion is matched only by our own."

the process

"Think, then do. Much of the process is purely thinking. Seeking out simpler, smarter solutions. Making it beautiful by any means possible whether it be a pencil or a mouse is a given. You can't have a beautiful book without a compelling story."

technology

"To quote an ad I read: 'Admire technology, worship its creator.' It's important to understand that technology is a tool, it doesn't think and cannot design. Garbage in, garbage out."

about type

"It's like casting—choose the players best suited for the part."

form and function

"It's like that old question…pretty or smart? To even be asked to the dance, any design today has no choice but to be both. Can't hide dumb behind a lot of make-up."

on music

"It's all good."

alternative career

"World-class windsurfer who paints."

more alternatives

"Astronaut. Scientist. Archeologist."

legacy

"There is such a rich history for a relatively young profession. Some early pioneers I admire are Paul Rand, Emil Ruder, Herb Lubalin, Armin Hoffman and Robert Miles Runyan. Not necessarily early but fixed in my inspiration admiration file are Jim Berte and Doug Oliver. Elegant solutions remembered."

forward

"It is a privilege to belong to this community. To serve as a voice for the Medici corporations and culture of our time. My only advice in its continuum is to remain intensely passionate because of the powerful position one has in creating what will become a chapter in the great book celebrating the human spirit."

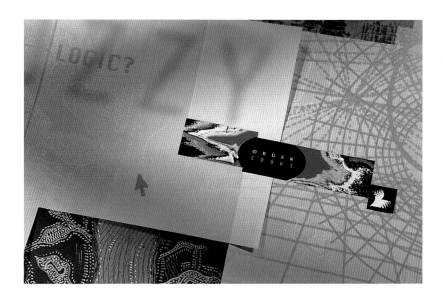

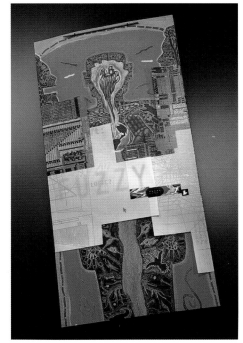

title: promotion calendar/"order:chaos"
description: design, print, paper promotion
design studio: louey/rubino design group inc./santa monica, ca
designer: robert louey

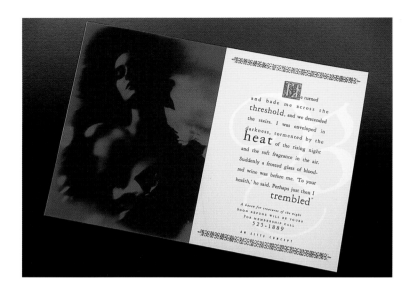

title: le bar bat
description: night club identity
design studio: louey/rubino design group inc./santa monica, ca
designer: robert louey
client: le bar bat

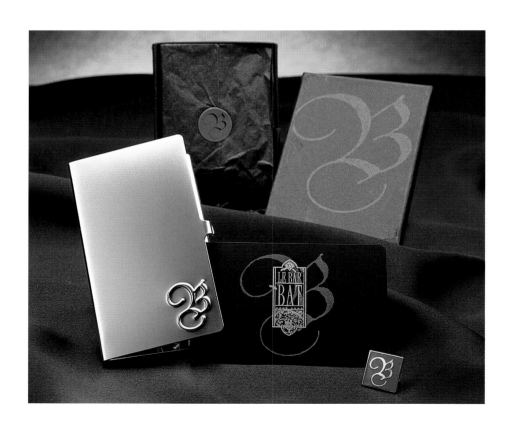

title: zen palette
description: restaurant identity and interiors
design studio: louey/rubino design group inc./
santa monica, ca
designer: robert louey
client: zen palette

title: grissini
description: restaurant identity
design studio: louey/rubino design group inc./
santa monica, ca
designer: robert louey
client: grissini

lanny sommese

sommese design/state college, pa

questions and answers

Q: What is the most unorthodox way you've come up with a design solution?

A: Hanging on a trapeze over the Suwannee River.

Q: What method of inspiration do you use repeatedly? What's your Method of Operation?

A: Problem analysis! Looking for something unique about the assignment that I can hang my creative hat on.

Q: What role does research play in *your* problem-solving process? Does research yield inspiration?

A: Research is very important to my process because I am interested not only in original solutions but relevant ones as well. Defining the problem fully is probably the best way to solve it. Besides, if it's not properly defined, how can I tell when I solved it?

Q: Has a client inspired you or influenced your creative process in a positive way?

A: The definition stage always includes the client. I get them involved early in order to ensure an appropriate solution that replies directly to their problem.

Q: What's your ideation process? Do you make thumbnail sketches?

A: Yes, I do thumbnails, though not as many as I used to. I seem to have worked long enough to recognize a relevant and unique and sellable solution right away. I look at a lot of thumbnails I did for projects years ago and I often wonder why I chose the one I did. Oh well!

Q: What role does technology play in the creative process?

A: Only after I have an idea and an image worked out, do I give it to my computer whiz kid to produce. (Sometimes I still do the production in the old way. YIKES!)

Q: Which typefaces can't you live without?

A: None! Actually I have done a lot of my type by hand since the computer made type so available. I like the hand-done quality, it seems to be appropriate to any imagery.

Lecture by the partners of Sommese Design, who are married and often see things differently.

title: lanny & kristin sommese lecture (cube) poster
design studio: sommese design/state college, pa
designer: lanny sommese
art director: kristin sommese
illustrator: lanny sommese
client: sommese design

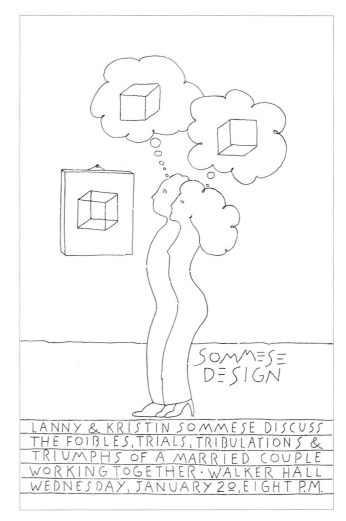

This poster was intended to be hung in schools in Pennsylvania to promote biodiversity.

title: "our living world — your life depends on it"
description: poster
design studio: sommese design/state college, pa
art director: lanny sommese
designer: lanny sommese
illustrator: lanny sommese
client: penn state college of agriculture

Q: Do you have a color palette that you return to over and over?

A: I usually try to use colors that are right for the assignment at hand. However, since most of my clients can't afford "full color," one- or two-color solutions are the norm for me and I find that I often think in terms of hand-separated colors.

Q: What is your opinion on form versus function?

A: The way my images look is always tempered by 1) the nature of the problem; 2) the audience; and 3) functional factors, such as budget, read-ability, etc. (I am never concerned much about personal expression.)

Q: Where do you go outside the design world for inspiration?

A: Everywhere! But I tend to gravitate toward "naiveté" (primitive art, etc.), perhaps because of the "high finish" of much contemporary design.

Q: Do you see the line between fine art and design diffusing?

A: I'm not in the least bit interested in fine art. Designers serve their clients, artists express themselves.

Q: Do you listen to music while you work? Which music?

A: I listen to talk shows and rock music and get pissed off about what they're serving up to my five-year-old.

Q: If you weren't a graphic designer, what would you want to be?

A: Politician. That's where the big Chinese yuans are.

Q: If you could instantly take on a new skill, what would it be?

A: Diplomacy. Then again, maybe not.

Q: Which graphic design pioneer is your hero?

A: Seymour Chwast. He's still going at the top levels of the profession after nearly fifty years. WOW!

Q: Do you dance swing? Mambo?

A: Only when I'm naked and want to show off my tattoo. (Just kidding.)

Q: What advice would you give a novice; what do you wish a seasoned designer had told you when starting out?

A: Get a broadly based education. Designers are moving farther and farther away from artists and their success depends on a lot more than the traditional handskills of the designer…more on thinking, speaking,

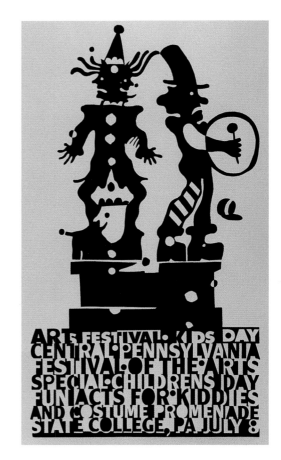

Silkscreen poster given away to participants in the annual summer event.

title: arts festival kids day
description: poster
design studio: sommese design/state college, pa
art director: lanny sommese
designer: lanny sommese
illustrator: lanny sommese

writing, business, etc., and contrary to popular opinion, designers are not all frustrated artists.

Q: What do you think of the state of the profession?

A: The state of design is OK! The problem is education. Schools are not very good overall. We need an accreditation procedure. No matter how big the bag-of-worms!

Q: How do you convince the client that they are not the designers?

A: Pull out a big gun! [See reply to question 4, above.]

Q: What responsibility do you take for creating the artifacts of our popular culture?

A: It's a big responsibility because more and more of those artifacts are the products of designers, not artists. Ironically, the ephemera we create will send a more detailed message about our culture to future generations. Overall, we don't think a lot about that. Hell, I'm trying to feed my babies.

This poster was intended to celebrate an innovative distance education program.

title: "innovations in distance education"
description: poster
design studio: sommese design/state college, pa
art director: lanny sommese
designer: lanny sommese
illustrator: lanny sommese
client: penn state university

title: "mountain laurels"
description: musical performance poster
design studio: sommese design/state college, pa
art director: lanny sommese
designer: lanny sommese
illustrator: lanny sommese
client: city of state college, pa

thomas c. ema

ema design inc./denver, co

Founder and principal of Ema Design Inc., Denver, Colorado, in 1982. Graduated from the Kansas City Art Institute (BFA, Design) under the chairmanship of Victor Papanek in 1979. Studied fine art at Virginia Tech, Blacksburg, Virginia, 1974–1976. Attended Kent State Summer in Switzerland workshop in 1984. Founding member and the first vice president of the American Institute of Graphic Arts, Colorado chapter.

Published in *Graphic Design: America, The Work of 28 Leading-Edge Design Firms from Across the United States and Canada* in 1993. Published in *Graphic Design America 2, The Work of Many of the Best and Brightest Design Firms from Across the United States* in 1997.

Thomas Ema develops design solutions that reflect his philosophy of balanced contrasts: "You have to listen to your client's needs with one ear. With the other ear, you have to listen to your own heart." Yet Ema's design style—rich with understated passion—is far from traditional. Look closely and you will see visual statements that strike a graceful balance between extremes: soothing textural patterns sheathed by hard-edged structural elements; large, bold type softened by italics; gloss and dull varnishes that transform two dimensions into three. "Having grown up in Williamsburg, Virginia, I have a deep appreciation for history and enduring quality," states Ema. Perhaps this explains why his work is imbued with a sense of timelessness that transcends trends and fads. Ema's childhood ardor for painting watercolor landscapes of the Blue Ridge Mountains found its sharp focus at the Kansas City Art Institute, where he studied Bauhaus design. He has said that he knew his schooling was complete when he "learned to paint with type."

Ema Design focuses on making ideas accessible through design. Principal Thomas Courtenay Ema and his staff begin their process by clarifying each client's communication objectives. "Once we identify and prioritize the benefits of their products or services, we look for connections that exist between those benefits and the world around us," says Ema. "We find metaphorical parallels or associations that become the seeds of our design approach. From there, we fill the functional need with a creative solution that is rooted in clear logic, but expressed through beauty." Ema believes that even the most solid and practical solution is best expressed with grace, rhythm and balance. "Many

people have told us that our work more than looks good—it makes them feel good," he says. "Maybe bringing a little beauty and warmth into the world is not a bad contribution to make today."

Q: What role does research play in your problem solving-process? Does research yield inspiration?

A: Research plays an important role in my problem-solving process. Maybe not in a direct, specific way, but definitely in helping define the problem and pinpointing the target audience and establishing the tone and flavor of the final solution. It influences the final solution by narrowing the appropriate directions and points us toward the right direction.

Q: What's your ideation process? Do you make thumbnail sketches?

A: After clearly defining the problem, I use my mind and creative instincts to formulate design concepts. Then I draw out, in a thumbnail approach, different ideas. Once this is done, we create them on the computer, constantly refining and developing the ideas until we feel we have the best solution to present to our client.

Q: What roles does technology play in the creative process?

A: I really view the computer as the means to an end. The computer is a tool that we utilize in our production process. I try not to let the computer influence our design approach although sometimes we will see pleasant surprises that we like and incorporate into a design. The computer is a great tool to refine and generate variations of a design to lead to the final solution.

Q: Which typefaces can't you live without?

A: Garamond No. 3 and Orator.

Q: Do you have a color palette that you return to over and over?

A: The colors I lean toward are primary colors and natural earth tones. I developed this sensibility through my formative years in painting, although recently I am more open to more unusual color combinations such as purples, oranges and greens.

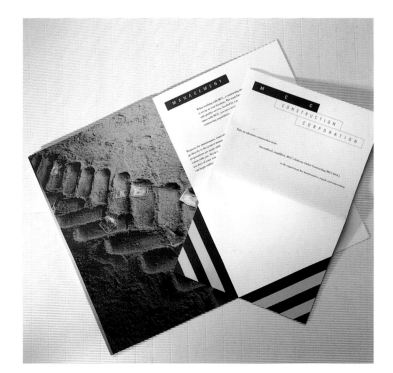

title: cyberlon construction
corporate brochure
design studio: ema design inc./denver, co
designer: thomas c. ema
client: cyberlon construction

title: tejeda annual report
description: promotional brochure for photographer
design studio: ema design inc./denver, co
art director/designer: thomas c. ema
client: tejeda

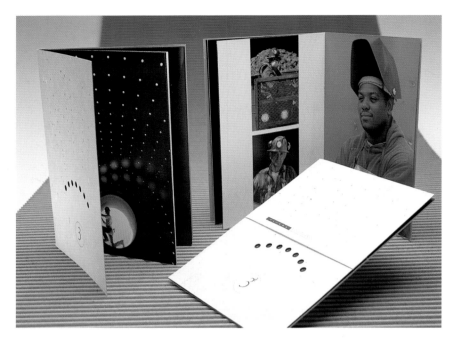

Q: What is your opinion on form versus function?
A: I believe that the form of a design should say something about the message that we are communicating. We try to make sure that every element of a design is there for a reason.

Q: Do you see the line between fine art and design diffusing?
A: I really do not see much of a line between fine art and design. If you look at design with an abstract perspective, it is very similar to good fine art. An example of this is looking at work from other countries and cultures. When you don't know the language of a piece, you are forced to perceive it in more fine art terms. I believe it is healthy to view your own work in this manner also.

Q: If you weren't a graphic designer, what would you want to be?
A: If I were not a graphic designer, I would enjoy being a photographer, architect or fine artist.

Q: Which graphic design pioneer is your hero?
A: Jan Tschichold.

Q: What responsibility do you take for creating the artifacts of our popular culture?
A: After working in the design field for nearly twenty years, my awareness of the contribution to our culture has increased. From the beginning of my career I have set out to create tasteful designs. Over the years, I feel good that I believe I have added a little beauty to the world around us. In the end, our legacy will be what we leave behind.

title: maggiano's corner bakery

description: exterior signage for restaurant and bakery

design studio: ema design inc./denver, co

art director: thomas c. ema

designers: thomas c. ema, prisca kolkowski

client: maggiano's corner bakery

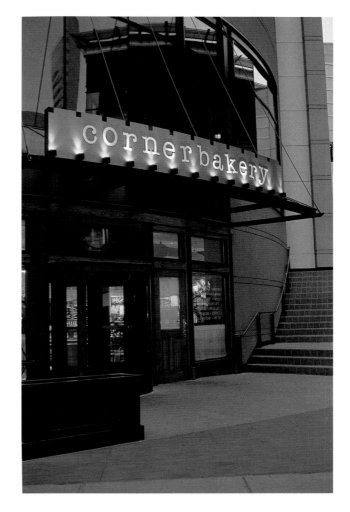

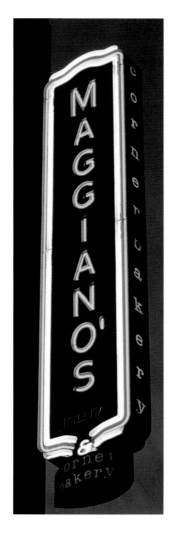

title: maggiano's corner bakery

description: exterior signage for restaurant and bakery

design studio: ema design inc./denver, co

art director: thomas c. ema

designers: thomas c. ema, prisca kolkowski

client: maggiano's corner bakery

david wheeler

lynnwood, wa

Q: What's your ideation process? Do you make thumbnail sketches?
A: My basic strategy is to come up with as many ideas (stupid or otherwise) as possible. Then the odds are better for getting to a successful solution. It's a lot like essay writing. First I try to restate the point of the article. Then I go to thumbnails to try to say it visually. It may sound very organized but it's just a lot of desperate doodling.

Q: What role does research play in *your* problem-solving process? Does research yield inspiration?
A: I am often given subjects to illustrate that I know very little about, so research helps me build a sort of visual vocabulary for the project. The more things I can use for a topic, the greater my chances of coming up with something interesting. Client input can be very helpful in this way if it is directed toward understanding the problem rather than stating the solution.

For example: I was working for a university magazine and I had the opportunity to be a part of the editorial meeting where we could discuss the text and what kind of interpretation was needed. The writing was interesting but it covered a lot of ground. Working with the editors and designer helped to focus my thinking and simplify my understanding of the material.

Q: What is your opinion on form vs. function?
A: For me it's all about communicating in the most interesting way I can. Form shifts to accommodate the statement. It makes the process more interesting for me.

Q: What role does technology play in the creative process?
A: I don't consider myself a computer artist, but I do use the computer to blow up sketches, print out patterns, etc. I do color sketches in Photoshop but end up changing the color all over again in the finished piece.

Q: Do you listen to music while you work? Which music?
A: Sometimes I'll choose different music to listen to while I work, depending on the tone I need for the project. It could be anything from jazz to James Brown, They Might Be Giants or Beck. If I'm getting tired or sluggish, I just turn on something that's loud and fast.

Q: What method of inspiration do you use repeatedly? What's your M.O.?
A: I look for inspiration everywhere. Most everything is interesting to me: history, science, politics, art history, NPR, the news, etc. Watching old movies and cartoons with the sound off also teaches me a lot.

Q: If you could instantly take on a new skill, what would it be?
A: Animation would be a nice skill to have. I haven't decided if I really want to learn how just yet, but if I could instantly have the skill, I think it would be fun.

Q: Which graphic design pioneer is your hero?
A: I couldn't pick just one graphic design hero. I admire a lot of people including: Saul Steinberg, Ben Shahn, A.M. Cassandre, George Grosz, Tommy Ungerer, Paul Davis, Seymour Chwast, Lane Smith, Heinrik Drescher, James Yang, Maurice Sendak…the list goes on and on.

Q: What responsibility do you take for creating the artifacts of our popular culture?
A: Humanities students of the future probably won't be required to memorize my name and dates, but I hope my work will be enjoyed in times beyond today. If someone twenty years from now is digging though the trash and finds my work in an old magazine, hopefully they'll smile and chuckle a little before recycling it.

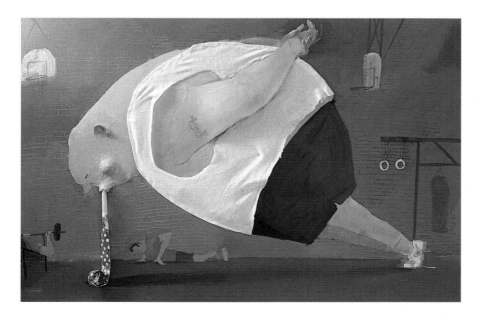

title: "man doing push-up: new year's resolution"
description: illustration for article on new year's resolutions
studio: david wheeler/lynnwood, wa
art director: skot o'mahoney
illustrator: david wheeler
client: *seattle* magazine

title: "cow & man at table: e-coli from beef"
studio: david wheeler/lynnwood, wa
illustrator: david wheeler
editor: tim steury
client: *universe* magazine
Illustration for a story about salmonella in beef.

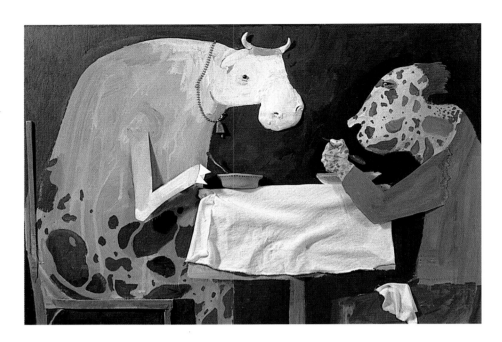

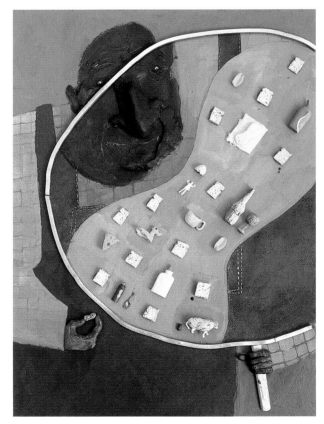

Part of a series on inventors; Carver was an inventor of numerous peanut products; self-promotion.

title: "portrait of george washington carver"
studio: david wheeler/lynnwood, wa
illustrator: david wheeler

Art for a story about McMansion Mania.

title: "2-car garage: oversized mansions"
studio: david wheeler/lynnwood, wa
art director: kristi anderson
illustrator: david wheeler
client: *utne reader*

Homeless sharing space in a dog pound in San Francisco.

title: "man housed in dog pound"
description: self-promotion
studio: david wheeler/lynnwood, wa
illustrator: david wheeler

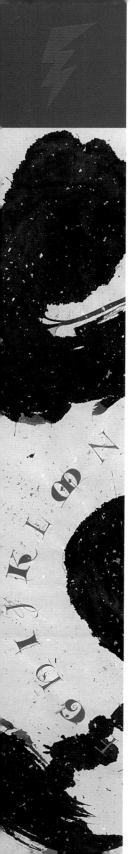

john stevens

john stevens design/winston-salem, nc

John is a calligrapher, designer of logotypes and illustrator of expressive letterforms with twenty years of experience. He has worked for well-known clients in book and magazine publishing, design, television and film, corporations and educational institutions. In addition to the graphics application of his work, John has practiced calligraphy as an art form, producing one-of-a-kind commissioned pieces that are included in many private and public collections throughout the world. He has had several solo exhibitions, including "Writing Considered As an Art" at the San Francisco Public Library and University of Portland at the International Calligraphy Conference in 1991, in addition to many group shows, the most recent one being the New York Society of Scribes' twenty-fifth anniversary exhibition, "Artist & Alphabet" in October 1999.

John's work has appeared in numerous books featuring the art of calligraphy and lettering.

Q: What method of inspiration do you use repeatedly?

A: Jotting down my first impressions as I listen to the client. I also jot down what I would like to see (in a perfect world) and then the practical course. I like to mix the rational with the intuitive. Thumbnail sketches and playing with forms, color and sometimes different tools can help the imagination. Looking at the problem from every view possible, to restate the problem, sometimes yields the direction. Writing down what we don't want is sometimes helpful. Technology is something I use once in while to look at situations from a different perspective or to test ideas from a production standpoint. I like to live with the problem for awhile, to get inside of it.

Q: What do you see as the role of research in your work?

A: At the risk of saying the same old things, research provides new information that in turn can yield new perspectives. I like when I have a problem that requires me to learn something and then to combine it with what I already know. The research doesn't provide the solution, but does offer a signpost to a different direction.

> Denise,
> I hope I'm not too late. Enclosed is a Zip disk with many things for consideration for your book. In addition, I've enclosed a bunch of things I could get my hands on quickly. If there is something you want to use, just let me know and I'll get you whatever is needed (trans, scan, etc.) I apologize for sending things like this, but time is something in short supply these days. Good luck w/ your book and thank you for inviting me to be a part of it. John Stevens

description: handwritten letter to denise m. anderson

title: "calligraphic triptych"
design studio: john stevens design/
winston-salem, nc
designer: john stevens
media: large wall hangings written with
various brushes on Japanese rice paper

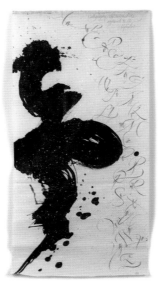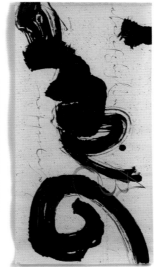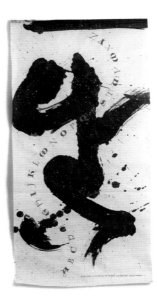

Q: What role does tech play in your work?

A: I'm not that dependent on technology; I did fine before it. In a way technology has taken some of the mystique out of things. It has created a context in which people assume it was done with a computer or a computer could do it, blah blah…I use it as either a tool to play with (in which case I usually have to produce the ideas by hand) or as a production tool (print, prepress or Web, etc.). It has helped and hindered, and I'm not sure which it has done more of.

Q: Which typefaces can't you live without?

A: The classics, like Bembo, Sabon, Centaur, Garamond, Perpetua….Not to say I don't like any new faces, I do. I have been influenced by what is happening today; however, I have been looking at letterforms and type for so long now that I get the sense that many things (including some of my own) are ephemeral, self-indulgent expressions or rip-offs. I personally have had enough of type that imitates hand-lettering.

I am in awe of the timeless beauty and TRUTH in those older designs, which I believe were designed in an environment that is different than what we have today. Rather than self-expression as a main goal, there was almost a quest for the perfect form, a reverence for the work, rather than a striving for attention and relevance. Not as a result of better people, just that things were different and the field attracted a different type of designer for a different purpose. Many designs of the past were a combination of history, aesthetics, "rightness" for use and what metal or wood would allow. The designer brilliantly incorporated the power of limits. The fact that forms created for metal punch cutting are still being used after 500 years says two things to me: 1) they were good; and 2) there is no true computer aesthetic. That is the difference between truth in design and derivatism. Type designers of the past knew how books were made, loved the history of it and learned from the masters

of the past because the truth is the truth. We think mostly in terms of style. In our trendy fashion-conscious, almost Hollywood-like, time we have responded accordingly. But hey, I may be wrong.

Q: What's your ideation process?
A: Thumbnails, doodles, marks, puddles, anything to start the process. Then a series of sketches that are more defined with a lot of give-and-take between organizing/ordering information and trying to keep it as fresh as the inspiration.

Q: What are your thoughts on form versus function?
A: My feeling is that this is not an either-or question. It's a contemplative question that one can use as a tool, sort of like a springboard for your left and right brain. It is always in flux and no one has been able to definitively say that one over the other matters more. Obviously, when you strike an agreeable balance your work will have more depth or dimension. It's really a judgment call. I think of it as a way into a problem but not the conclusion. Come to this from a function point of view and see how it impacts form and vice versa. I think it's a game that artists and designers like to play and need to play. Besides, haven't we had enough of either-or thinking? I catch my students with this one all the time.

Q: What do you enjoy outside the design world?
A: Being alone in nature, nature and history, child art, vernacular stuff all over the place, reading unrelated stuff, talking to people and teaching.

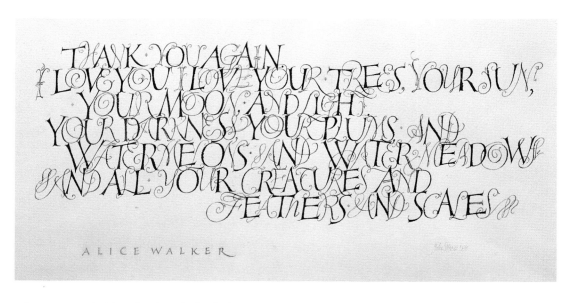

title: "creatures" (words of alice walker, *the temple of my familiar*)
design studio: john stevens design/winston-salem, nc
art director/designer/artist/calligrapher: john stevens
media: calligraphic art written with pen on rough watercolor paper and 23K gold leaf (for exhibition)
publisher: harcourt, brace, jovanovich, 1989

Q: Do you listen to music when you work?

A: Yes, I do. I was once a musician and that's the other profession I would pick if I weren't a graphic designer. I listen to everything, but specifically right now I'm listening to: Jeff Beck *(Who Else!)*, Sheryl Crow *(The Globe Sessions)*, King Crimson *(Larks; Tongues in Aspic)*, Gabrielle Roth, Ani DiFranco and James Brown as well as the Rhino British Invasion stuff.

Q: If you could instantly take on a new skill…

A: Metal work or stone carving.

Q: Who are your design heroes?

A: Paul Rand, Milton Glaser, Herb Lubalin, Hermann Zapf.

Q: How do you convince the client that they are not the designers?

A: If they need convincing, I try to show them that they are costing themselves by getting in the way, and that their role is criteria input and feedback. I'll write a design proposal and tell them that I have their objectives in mind, but to leave the subjective to me—that is my language and what they hired me for. If they have a good idea, I will tell them, but I still have to go through a process to let the best idea surface. I never let the client dictate aesthetics. I think that in the end if the client demands to play designer, we probably won't be able to work together.

Playful logo experiment for the Downtown Artists District Association.

title: "dada (s)"
design studio: john stevens design/winston-salem, nc
designer/calligrapher: john stevens
client: downtown artists district association

Playful logo experiment for the Downtown Artists District Association.

title: "dada boxed"
design studio: john stevens design/winston-salem, nc
designer/calligrapher: john stevens
client: downtown artists district association

jilda morera
jilda morera photography/palm harbor, fl

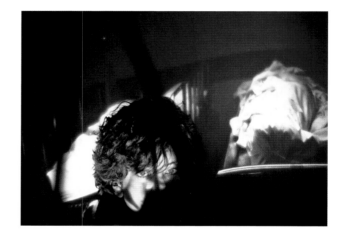

"I need photography; it has never been just a form of expression, but rather a way to remove images from my mind—they collect like cobwebs that must be periodically dusted away.

"First, the image, in some rudimentary form, develops and then I photograph it either as a 'found object' or as an intricately manipulated still life. I even feel a physical sensation when an idea comes to mind. Suddenly I see the image, I feel it. I see it so clearly I can almost taste it. A fluttering in the pit of my stomach grows until I take the shot, all the while praying I didn't somehow botch it up! Ironically, it is the shot that I initially feel is lacking that inevitably turns out to impress me. This process keeps me humble, I suppose. I never get too cocky since I truly don't know for certain if what my mind, my eye and my camera see are all in alignment until I see the film."

On Inspiration
"One image inspires another image. From there it snowballs, idéas collect. Often, when on location, I find myself breathless and in anticipation, anxious, checking and rechecking my camera like a neurotic Virgo (incidentally, I'm a Scorpio), all the while with that fluttering in my belly, until the shot is secured. Once on film, the symptoms subside and I can once again breathe. The greater the physical discomfort, the greater the shot seems to be."

title: "to the core"
description: photograph
studio: jilda morera photography/palm harbor, fl
photographer: jilda morera

"Tired of shooting goody-two-shoes types of shots, I decided to be bold, disturbing, shocking (not to mention my model/cousin had a most gruesome bruise, so I didn't need to use the make-up I bought to make her look dead)," explains Jilda Morera.

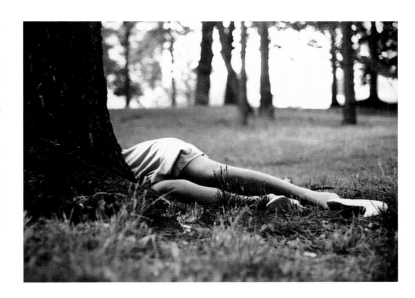

title: "dead woman"
description: photograph
studio: jilda morera photography/
palm harbor, fl
photographer: jilda morera

title: "the recipe"
description: photograph
studio: jilda morera photography/palm harbor, fl
photographer: jilda morera

title: "blood orange"
description: photograph
studio: jilda morera photography/palm harbor, fl
photographer: jilda morera

jennifer morla

morla design/san francisco, ca

Q: What's your ideation process? Do you make thumbnail sketches?
A: I conceptualize while the client is talking, do quite a few very loose sketches (mainly so I don't forget those ideas). I move onto the computer to finalize the layout.

Q: What role does technology play in the creative process?
A: A little, a lot.

Q: Which typefaces can't you live without?
A: Helvetica, Futura, Courier.

Q: Do you have a color palette that you return to over and over?
A: Black and white. The most bang for the buck.

Q: Do you see the line between fine art and design diffusing?
A: Fine art is communicating the artist's message, utilizing tools that were once exclusive to the design profession. As well, as marketing directors become more savvy about youth markets, designers are able to create far more abstract solutions.

Q: Do you listen to music while you work? Which music?
A: Yes, Massive Attack, *Paris* by Malcolm McLaren, *Buena Vista Social Club* Soundtrack (Cuban) or Sarah Vaughan.

Q: If you could instantly take on a new skill, what would it be?
A: Sailing.

Q: Which graphic design pioneer is your hero?
A: Alvin Lustig.

Q: How do you convince the client that they are not the designers?
A: The client is an integral part of the design process. Creative concepts are based on listening to your client. Try to guide them down the right creative path at your very first meeting. Don't be selfish with your concept: let the client feel as if your joint effort yielded their award-winning piece.

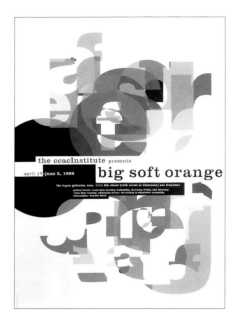

title: ccac institute, "big soft orange"
description: poster
design studio: morla design/san francisco, ca
art director: jennifer morla
client: california college of arts and crafts

California College of Arts & Crafts's new San Francisco architecture and design building required a recruitment announcement poster. The imagery of the large bolt and energetic typography collide to symbolize the process of creating the new campus. In addition, the measuring rules and printer's registration bar act as a metaphor for the entirety of the design disciplines.

title: ccac institute, "new building"
description: poster
design studio: morla design/san francisco, ca
art director: jennifer morla
designers: jennifer morla, petra geiger
client: california college of arts and crafts

This series of exhibition announcements was designed for the CCAC Institute, one of San Francisco's newest experimental art venues. Working with extreme budget constraints, each poster incorporates letters from the show's title to create dynamic graphics that give each show a unique visual voice. Applied as barricade posters, they create a dynamic presence when used in multiplicity. The experimental typographic vocabulary reflects the nature of the art shown and creates a recognizable identity for the CCAC Institute.

title: ccac institute, "spaced out"
description: poster
design studio: morla design/san francisco, ca
art director: jennifer morla
designers: jennifer morla, sara schneider
client: california college of arts and crafts

title: ccac institute, fabrice hybert
description: poster
design studio: morla design/san francisco, ca
art director: jennifer morla
client: california college of arts and crafts

carlos segura

segura inc./chicago, il

Segura Inc. was born from the frustrations of Carlos Segura's thirteen-year career in advertising, opening its doors in January 1991 to pursue design and its tangible and personal possibilities. Drawn to the print medium, all forms of materials were based on three basics: typography, papers and fine art. Fueled by curiosity, experimentation was a primary direction in all efforts leading to the development and creation of [T-26], a new digital type foundry, which debuted in fall 1994. Another form of expansion has been multimedia, Web site and interactive presentations, all with the philosophy that "communication that doesn't take a chance, doesn't stand a chance."

Segura is one designer who fuses creative ideas with the creative manipulation of the physical elements. Every piece from Segura Inc. is a visual surprise.

title: segura stationery system
design studio: segura inc./chicago, il
art director: carlos segura

title: [t-26] poster
design studio: segura inc./chicago, il
client: [t-26]

title: yosho identity system
description: identity system for new media company
design studio: segura inc./chicago, il
creative director: carlos segura
designer: teeranop wansillapakun
client: yosho

title: [t-26] supplement #22
design studio: segura inc./chicago, il
art director: carlos segura
client: [t-26]

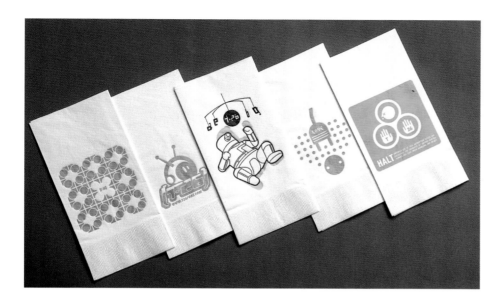

title: [t-26] napkins
design studio: segura inc./chicago, il
designer: carlos segura
client: [t-26]

 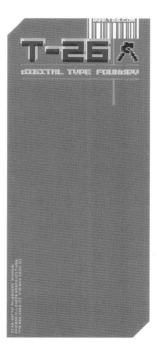

title: [t-26] labels
design studio: segura inc./chicago, il
art director: carlos segura
client: [t-26]

Be Bold.

kiku obata

kiku obata & company/st. louis, mo

"Brown Shoe Company, formerly The Brown Group, is a wholesale manufacturer and distributor of women's, men's and children's footwear worldwide. Kiku Obata & Company designed a comprehensive brand identity program for Brown Shoe. The temporary signage on the company's headquarters in St. Louis lets the public know of the company's new identity and creates anticipation of new things to come."

title: brown shoe company comprehensive brand identity program
design studio: kiku obata & company/st. louis, mo
photographer: greg goldman/st. louis, mo
client: brown shoe company/st. louis, mo

"When Brown Shoe launched the new name and logo at their shareholders meeting, Kiku Obata & Company developed a promotional 'shoebox' that was given to all shareholders. It contained a T-shirt, stickers, foot lotion and marketing materials that answer questions about the new identity."

title: brown shoe company comprehensive brand identity program
design studio: kiku obata & company/st. louis, mo
photographer: greg goldman/st. louis, mo
client: brown shoe company/st. louis, mo

"Street banners announce the company's new name and identity."

title: brown shoe company comprehensive brand identity program
design studio: kiku obata & company/st. louis, mo
photographer: greg goldman/st. louis, mo
client: brown shoe company/st. louis, mo

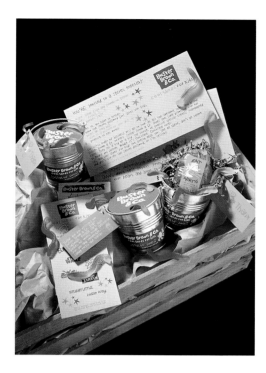

"Buster Brown & Co. is the kid's division of Brown Shoe Company. Kiku Obata & Company developed a kid-focused brand identity for Buster Brown that included a logo, trade show booth, packaging and promotional/marketing materials. Guests to the trade show booth were given a 'bucket of worms,' complete with green grass and gummy worms as a thank-you for visiting."

title: brown shoe company comprehensive brand identity program
design studio: kiku obata & company/st. louis, mo
photographer: greg goldman/st.lLouis, mo
client: brown shoe company/st. louis, mo

The new logo for Brown Shoe Company is an abstract representation of both a "B" and a pair of shoes. The simple and clean design suggests a footwear company "on the move" and represents Brown Shoe's mission to be "The Leader in Footwear."

The advertising program combines lifestyle photography and bold copy to create a fresh, contemporary identity.

title: brown shoe advertising program
design studio: kiku obata & company/st. louis, mo
photographer: greg goldman/st. louis, mo
client: brown shoe company/st. louis, mo

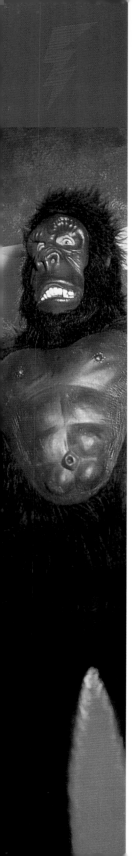

hunt adkins

minneapolis, mn

our creative philosophy

We demonstrate respect for the intelligence of our audience by presenting the truth in a uniquely entertaining fashion, rejecting formulaic, tired thinking for surprising unconventional solutions.

There was a time when it was okay to repeatedly poke someone in the eye with a sharp stick, as long as you did it with a reach of 85 and a frequency of 12.

But the truth is, people are tired of the hard sell of advertising. They're tired of being overwhelmed with a relentless barrage of irrelevant features and benefits, tired of being pounded into submission by mindless drivel, tired of being poked in the eye.

People now expect advertising to not only be painless, but even—dare we say it—enjoyable. The Super Bowl isn't judged so much by the final score as by the entertainment value of the accompanying advertising.

In terms of graphic design, esoteric and oblique translate to inefficient and ineffective. Graphic design must communicate clearly in ways that leverage relevant messages of interest to the consumer. Not unlike great advertising, graphic design should engage, inspire and move people to act in a desired way.

It all boils down to this: We must understand consumers—both where they're coming from and the perspective from which they make their purchasing decisions. And then engage and entertain, speaking to people rather than at them. And no sharp sticks.

title: "pitcher's mound"
description: bus shelter ad for minnesota twins
design studio: hunt adkins/minneapolis, mn
art director: steve mitchell
copywriter: doug adkins
client: minnesota twins

title: dublin photography, "gorilla,"
"beef boy," "lumberjack"
description: direct mail postcards
design studio: hunt adkins/
minneapolis, mn
art director: brock davis
copywriters: doug adkins,
ned brown-stearns
photographers: joe lampi,
kerry peterson, doug baartman
client: dublin photography

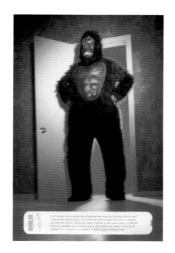
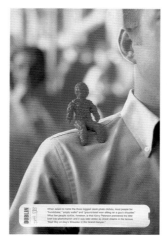
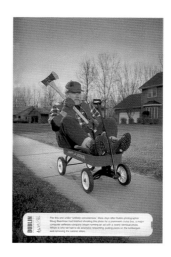

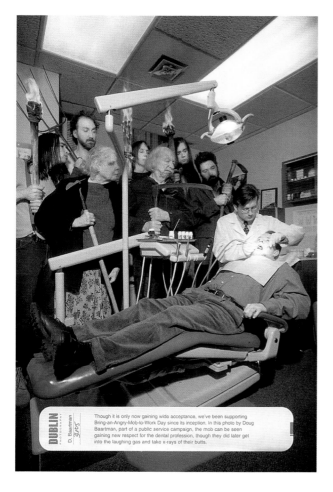

title: dublin photography, "dentist"
description: direct mail postcard
design studio: hunt adkins/
minneapolis, mn
art directors: brock davis,
steve mitchell
copywriters: doug adkins, ned brown-stearns
photographers: doug baartman, kerry peterson
client: dublin photography

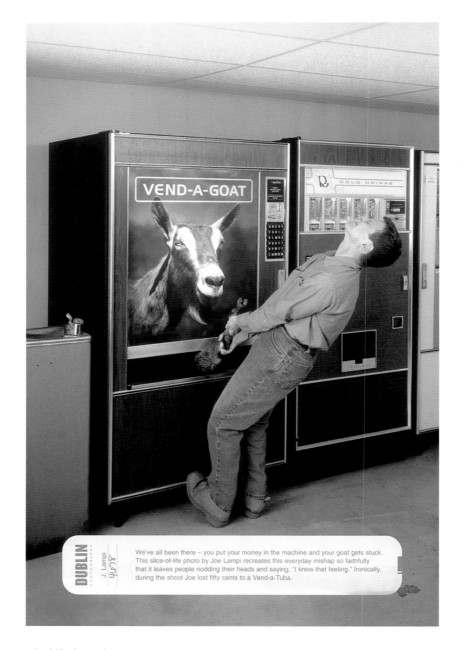

title: dublin photography, "goat"

description: direct mail postcard

design studio: hunt adkins/minneapolis, mn

art directors: steve mitchell, brock davis

copywriters: doug adkins, ned brown-stearns

photographer: joe lampi

client: dublin photography

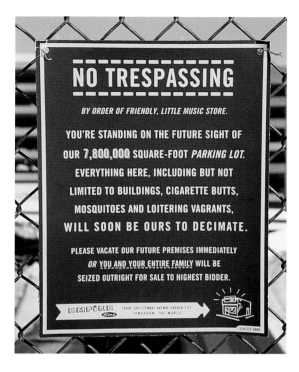

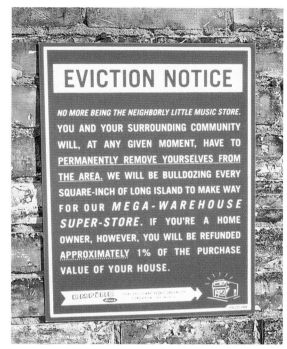

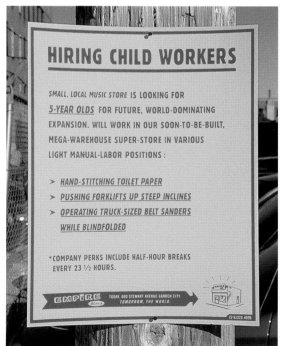

title: empire discs, "no trespassing," "eviction notice,"
"hiring child workers"
description: posters
design studio: hunt adkins/minneapolis, mn
art director: addy khaotang
copywriter: ned brown-stearns

george tscherny

george tscherny, inc./new york, ny

Q: What is the most unorthodox way you've come up with a design solution?

A: Recently I completed an outdoor sign program, which is unusual in that it utilizes both the front and back sides of directional signs.

As a graphic designer, I have always felt (and practiced) that brochures with bareback covers missed an additional opportunity to communicate, impress or entertain. Ditto for signs.

Therefore, when we embarked on a directional sign program at a new headquarters site for SEI Investments (see page 138), I wondered if the theory of wrap-around cover designs couldn't work here as well. Get them *coming* and *going*.

However, we first had to find a way to eliminate the post that runs up the back of most freestanding signs. The solution was to have two metal bands form a "Y" that cradles the diamond-shaped panels.

The important thing to remember is that these abstract patterns are just a fun byproduct on the back of signs that exist primarily to guide and direct employees and visitors at SEI's office compound.

With the exception of the yellow and red traffic signs, the backgrounds of all directional signs are a middle-tone gray, creating a neutral environment for the pictorial back panels, which range from a stark black and white to a multi-colored palette.

Within this geometric design vocabulary there was ample opportunity to explore a wide variety of patterns, creating optical illusions through minute modulations and transforming a 2-D image to a (seemingly) 3-D image by means of a progression of black, grays and white.

The objective here is to *communicate* when people are entering the site and to *entertain* when they are leaving.

Q: What's your method of operation?

A: I have always pursued two opposite directions in my work: 1) to extract the essence of a subject and present it simply and dramatically; and 2) to utilize a scrapbook technique, when that approach seemed useful, in order to intensify the communications process.

Q: Which typefaces can't you live without?

A: For me the choice of typeface is less significant than how it is used.

Moreover, easy access to typefaces brought about in the 1960s by photocomposition and further accelerated by the computer is responsible for a great deal of "hype with type" that has caused me to resort to handwriting when appropriate.

The handwritten message is a reflection of the writer and can humanize a formal corporate or institutional message. It doesn't take itself too seriously and projects an immediacy that is difficult to achieve with type.

Q: Do you have a color palette that you return to over and over?

A: In 1974, AIGA held an art exhibition and auction with a theme of COLOR. My statement at the time might still do as an answer to your question:

"So how does color work in our minds? We're fortunate to have these answers—each one a personal working-out of a personal vision. Perhaps this public display can lead us to a private understanding of how it works in our own minds through a rare opportunity to see color at work in the minds of others. And speaking in a form that is perhaps as close to color as words get *George Tscherny* has the last word."

Q: Where do you go outside the design world for inspiration?

A: I am a collector. However, my collections are not of the conventional kind, like decoy ducks or glass paperweights.

I have a penchant for investigating minor subjects that are often overlooked, like Odd & Even, a study of house numbers. Even with overworked subjects like flowers (1991 calendar), my point of view is less horticultural and more of the human experience.

When I started work on "Pull and Let Go" brochure for Champion (see page 139), I sent an assistant to the library to search for material on toilet pulls. At the end of the day she telephoned with the bad news that she couldn't find a thing, and the good news: *nobody* had done anything on toilet pulls.

You might say that I look for *poetry in everyday life* as in the 1999 calendar.

title: 1999 calendar, "seeing the poetry in everyday life"
design studio: george tscherny, inc./new york, ny
design: george tscherny, inc.
photographer: george tscherny
client: putnam, lovell, de guardiola & thornton

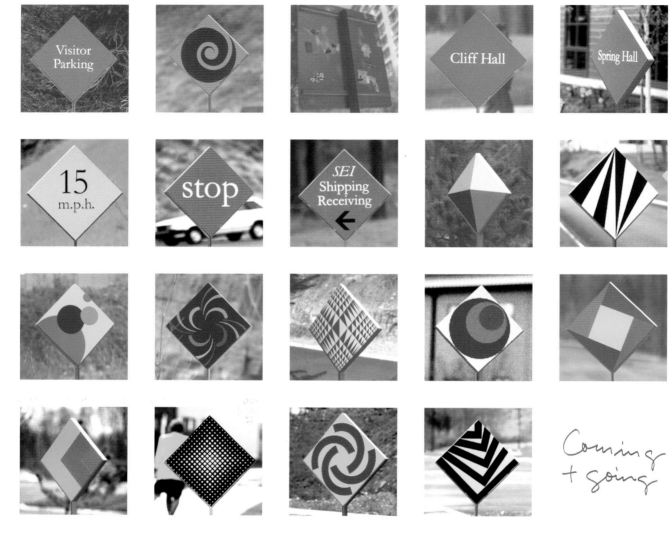

title: sei directional sign program
design studio: george tscherny, inc./
new york, ny
design: george tscherny
fabricator: ags
client: sei investments

title: "pull and let go"
description: design and communication for w.c.
design studio: george tscherny, inc./new york, ny
design, text, photography: george tscherny
client: champion papers

title: "congratulations sva"
description: promotional literature
design studio: george tscherny, inc./new york, ny
art director: george tscherny
client: school of visual arts/new york, ny

copyright notices

index